SIR EDWARD BURNE-JONES

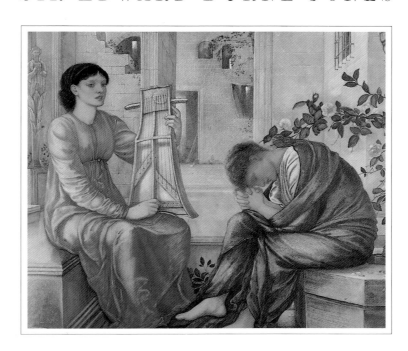

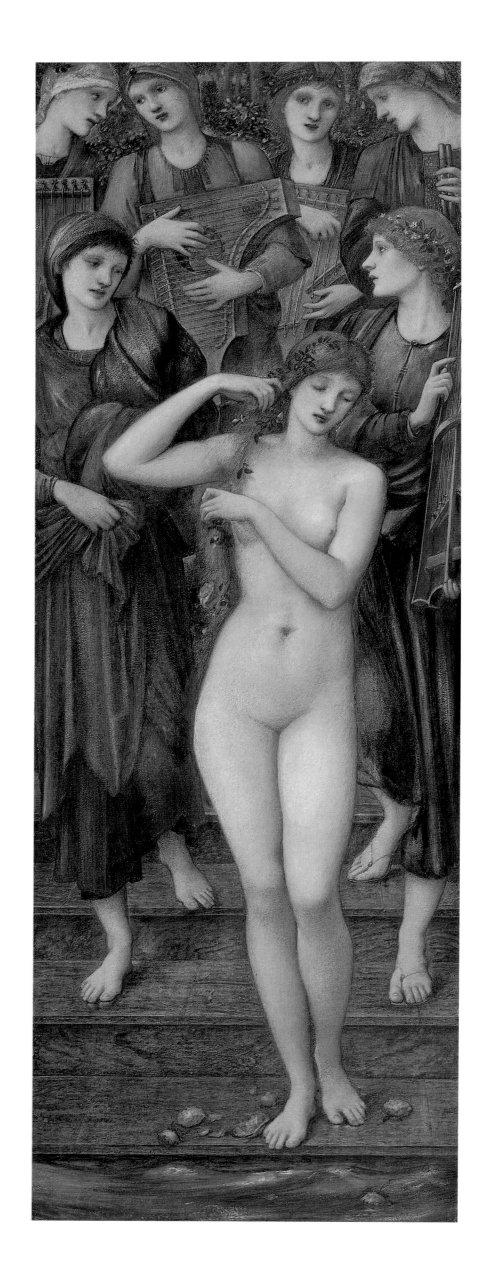

SIR EDWARD
BURNE-JONES

Russell Ash

PAVILION

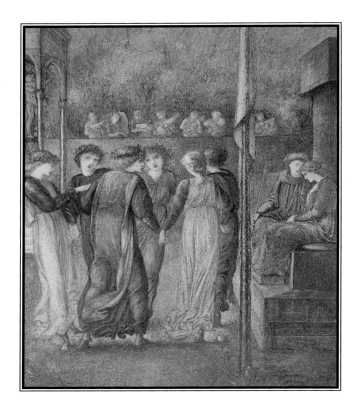

First published in 1993 by
PAVILION BOOKS LIMITED
196 Shaftesbury Avenue, London WC2H 8JL

Produced, edited and designed by Russell Ash & Bernard Higton
Text copyright © Russell Ash 1993
The moral right of the author has been asserted.

Designed by Bernard Higton

Picture research by Mary-Jane Gibson

A CIP catalogue record for this book is available from the British Library.

ISBN 1 85793 017 7 (hbk)
ISBN 1 85793 123 8 (pbk)

Printed and bound in Italy by Mondadori

2 4 6 8 10 9 7 5 3 1

PICTURE CREDITS

Half-title: *The Lament* (1866), William Morris Gallery, Walthamstow.
Frontispiece: *The Bath of Venus* (1873–88), Calouste Gulbenkian
Foundation, Lisbon.
Above: *King René's Wedding* (1870), Roy Miles Gallery/Bridgeman Art
Library.

Portrait of Burne-Jones by George Howard and Dante Gabriel Rossetti
photographed by Lewis Carroll: National Portrait Gallery, London.
Burne-Jones's birthplace and self-caricature of his Red Lion Square
home: from *Memorials of Edward Burne-Jones*. *The Annunciation, The Flower
of God* and *St Martin* stained glass design: Christie's Images. Photographs
of the Burne-Jones and Morris families and Burne-Jones and his grand-
daughter: Hammersmith & Fulham Archives & Local History Centre.
Pilgrim at the Gate of Idleness: Roy Miles Gallery/Bridgeman Art Library.

The Knight's Farewell: Visitors of the Ashmolean Museum, Oxford. *The
Wedding of Sir Tristram*: Corporation Art Gallery, Bradford/Bridgeman
Art Library. Portrait of Maria Zambaco: Private collection. *Hope*:
Christie's/Bridgeman Art Library. *Phyllis and Demophöon*: Birmingham
Museums and Art Gallery. *Evening Star*: Private collection/Bridgeman
Art Library. Photograph of John Ruskin: Private collection. *The Adoration
of the Magi*: Norfolk Museums Service (Norwich Castle Museum). *Houses
at Rottingdean*: Sotheby's, London. Detail from *The Last Sleep of Arthur in
Avalon*: Museo de Arte, Ponce, Puerto Rico. Kelmscott *Chaucer*: William
Morris Gallery, Walthamstow. *Portrait of Katie Lewis*: Private collec-
tion/Bridgeman Art Library. Letters to Katie Lewis: British Museum,
London. All colour plates were supplied by and are reproduced with the
permission of the collections indicated. Additional photo credits:
Bridgeman Art Library, London; Christie's Images, London; Service
Photographique de RMN, Paris.

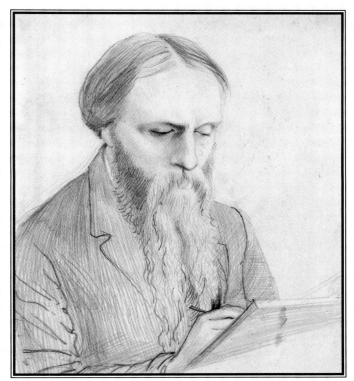

Portrait of Edward Burne-Jones by his patron, George Howard, 9th Earl of Carlisle (c.1875).

The name of Burne-Jones is synonymous with the history and achievements of the Pre-Raphaelites, yet he was a relative latecomer to the movement and in many respects transcended its aspirations, becoming regarded as the leader of the Aesthetic Movement, a precursor of Symbolism, and one of the most pivotal figures in nineteenth-century art.

Edward Coley Burne Jones was born in Birmingham on 28 August 1833. The hyphenation of his name to Burne-Jones was an affectation he adopted in later life to avoid the obscurity of being 'one of the Joneses' (his contemporary, Lawrence Alma-Tadema, had done the same thing in order to appear at the head of alphabetical catalogues). His three names came from, respectively, his father, Edward Richard Jones, a Londoner who had settled in his wife's native city, where he had established a modest business as a gilder and framer with premises on Bennett's Hill, Birmingham; Coley from his mother, Elizabeth Coley; and Burne from the married name of his aunt Keturah Jones. A previous child, Edith, had died, and Mr and Mrs Jones had every hope of restoring their happiness through their new son, but this aspiration was dashed when, on 3 September, six days after Edward's birth, Elizabeth died. This tragic sense of loss was to characterize Edward's relationship with his father, as he later considered: 'There's one thing I owe to my father, that is his sense of pathos. Oh, what a sad little home was ours and how I used to be glad to get away from it.' Edward Jones Snr was thrifty but not commercially skilled. Every penny had to be counted, and it was in this gloomy environment, in a grimy industrial city, with little in the way of artistic stimulation, that Edward Burne-Jones grew up.

Following his mother's death, Edward was cared for by a succession of largely incompetent nannies until a Miss Sampson arrived, remaining in the household for the rest of her life. Although she appears to have been considerate of his needs — he was always frail, and she took him on country visits to build up his strength — she constrained his enquiring mind and imagination (a devout Christian, she told him, for instance, that it would be sinful to call a model city he had built 'Jerusalem'). Edward grew up deeply introspective: his answer when Miss Sampson asked what he was thinking about was invariably the dismissive 'camels'. One route out of this repressive atmosphere, as many only children have discovered, was to devote himself to reading, and among his favourite books in this largely un-bookish house was *Aesop's Fables*. A family friend called Caswell encouraged his drawing ability, and he was sensitive to such images as Birmingham offered. Among his earliest memories was the pageantry associated with the city's celebrations of the coronation of Queen Victoria, on 28 June 1838, when he was not quite five years old. 'Unmothered, with a sad papa, without sister or brother, always alone,' was how he looked back on his childhood, and yet, he recalled, 'I was never unhappy because I was always drawing.'

Edward's father wanted him to pursue a career in commerce, or perhaps become an engineer, and at the age of 11 he was enrolled in the old-established King Edward's School, Birmingham. The school's neo-Gothic buildings, since demolished, had been designed 10 years earlier by Sir Charles Barry and Augustus Pugin, the architects responsible for the Houses of Parliament. It was a notoriously strict establishment, where corporal punishment and bullying were rife (on one occasion Burne-Jones was even stabbed during morning prayers), yet he not only survived but became head boy in his final year and flourished academically, invariably placed top of his class. When, later in life, he came to compare his knowledge of subjects such as Latin and history with that of his closest friend, William Morris (who had attended Marlborough, one of Britain's greatest schools, and had private tutors), he was astonished to discover that he exceeded him on all counts. With his schoolfriend Cormell Price, later a noted educationalist, Burne-Jones studied books of heroic legends and, at the age of 15, created a small museum and embarked on the grandiose and romantically unrealistic project of writing a history of the world. Meanwhile, he began attending art classes at the local School of Design, initially as an adjunct to his historical researches. Immensely widely read, he developed an extensive general knowledge and, with his enthusiasm for researching even the most trivial detail, laid the foundation for the later studies that were of direct importance in his artistic development. He became fascinated by religion, and visits to Hereford cathedral enhanced his growing interest in formal Christianity, which was further influenced by the publicity given to the High Church Oxford Movement led by Cardinal Newman. He later acknowledged how

Burne-Jones's birthplace, Bennett's Hill, Birmingham, by Frederick Griggs.

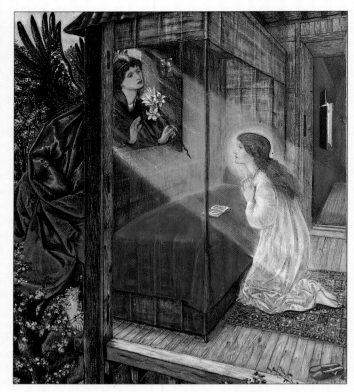

The Annunciation, The Flower of God (1862). Burne-Jones's deep religious beliefs pervaded much of his early work.

Newman's teachings had affected him during his formative years: 'When I was 15 or 16 he taught me so much I do mind — things that will never be out of me. In an age of sofas and cushions he taught me to be indifferent to comfort, and in an age of materialism he taught me to venture all on the unseen.' Until circumstances altered his life for ever, Burne-Jones seemed destined for a career in the church.

In his teens Burne-Jones visited remote places in Wales, and became passionate about medieval abbeys. Staying with his aunt Keturah in London, he saw St Paul's Cathedral and other impressive buildings and made numerous trips to the British Museum where he drew the Assyrian bas-reliefs, describing them in detailed letters home. His love affair with the Museum lasted throughout his life, and one of his most personal productions, his *Flower Book*, was donated to it on his death. In 1852 he visited the home of his school-friend Harry Macdonald and there, among the large group of Harry's sisters, first met Georgiana Macdonald who was later to become his wife and biographer. She was to recall this first meeting and provide one of the earliest descriptions of the young Burne-Jones:

'His aspect made the deepest impression upon me. Rather tall and very thin, though not especially slender, straightly built and with wide shoulders. Extremely pale he was, with the paleness that belongs to fair-haired people, and looked delicate, but not ill. His hair was perfectly straight, and of a colourless kind. His eyes were light grey (if their colour could be defined in words).'

Burne-Jones went up to Exeter College, Oxford, in January 1853. His father had to move from their Bennett's Hill home and workshop to a small house in Birmingham's Bristol Road in order to make the necessary economies to afford to send him to university. When, the previous June, he had sat examinations, Burne-Jones first saw, but did not speak to, William Morris. Now he met him and became an immediate and close friend — to the extent that the latter, being wealthier than Burne-Jones, offered to share his income with him (which, characteristically, Burne-Jones declined). The pair were regarded as oddities among a rather raucous group of men in their college, and, with a mutual dislike of Exeter, they spent most of their time with an ex-Birmingham clique in Pembroke College. There they developed the notion of founding a brotherhood (coincidentally, since they were as yet unaware of it, in some respects an emulation of the Pre-Raphaelite Brotherhood founded during the previous decade). It had the quest for the Holy Grail and the chivalric ideals of Sir Galahad as its guiding ideals in a campaign against what they regarded as the industrial horrors and moral decline of the age. Coupled with this crusading zeal, Burne-Jones developed his interest in medieval romance literature, with its particular appeal of a mysterious, unexplained, occult world. He and his compatriots were also enthusiastic devotees of Tennyson's works, for their insights into the medieval age, and such modern writers as Edgar Alan Poe. For recreation, Burne-Jones took up fencing, and his teacher, the eccentric Archibald Maclaren, encouraged his continuing interest in drawing.

During 1854 Burne-Jones and Morris ('Ned' and 'Topsy', as they called each other — Topsy from the character in *Uncle Tom's Cabin*, first published in England in 1852) continued their varied studies and got into habit of reading aloud to each other. It was from one such session, a transcript of one of John Ruskin's lectures, that they first learned about the Pre-Raphaelites and heard the name of Dante Gabriel Rossetti, one of the founders in 1848 of the Pre-Raphaelite Brotherhood. With John Everett Millais, William Holman Hunt and other like-minded young artists, Rossetti had sought to break away from the academic subjects then in vogue, with the aim of creating a pure art founded in social realism, inspired by the poetry of Keats and Tennyson and focusing on noble medieval themes. In

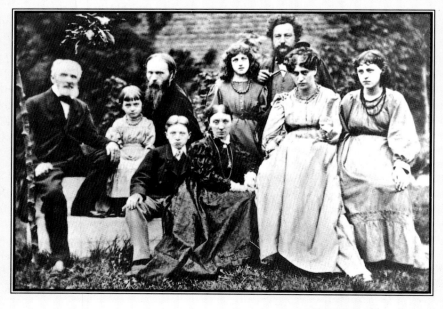

The Burne-Jones and Morris families at The Grange in 1876. Left to right: Edward's father, Margaret, Edward, Phillip and Georgiana Burne-Jones, with May, William, Jane and Jenny Morris.

reality, they had worked little as a group, and by 1854 no longer existed as a coherent movement. Nonetheless, Burne-Jones and Morris became aware of their work, the first example of which they saw was Millais' *Return of the Dove to the Ark* when it was exhibited in Oxford. Burne-Jones's response was to begin working in pen and ink in a minutely detailed and increasingly Pre-Raphaelite style, illustrating a fairy book by Maclaren. He visited London and at the Royal Academy saw Holman Hunt's controversial paintings *The Awakening Conscience* and *The Light of the World*, later commenting that, 'I saw that the Pre-Raphaelites had indeed come at a time when there was need for them, and resolved after my little ability to defend and claim a patient hearing for

Originally conceived as an embroidery design, *Pilgrim at the Gate of Idleness* (1875–93) exemplifies Burne-Jones's lifelong fascination with medieval themes.

them.' Back at Oxford, with Morris, he continued in his studies of medieval manuscripts, now with a fresh impetus and goal.

In 1855 Burne-Jones toyed with the idea of joining the army to fight in the Crimean War, but was rejected on health grounds. He visited London and went to inspect the paintings of a collector who owned Ford Madox Brown's *The Last of England* and works by Millais. He also saw paintings by Holman Hunt in an Oxford collection and read Rossetti's *Blessed Damozel*, coming increasingly to idolize him as the undisputed leader of the Pre-Raphaelites. During the long vacation in 1855 Burne-Jones visited France with Morris and two other friends, taking in Beauvais Cathedral, Paris and Chartres, as well as dozens of medieval churches en route. Almost as a culmination of their years of studies and their recent exposure to a feast of medieval architecture, it was on the quay at Le Havre that the dramatic decision was taken that was to chart the rest of their lives: Morris would train as an architect and Burne-Jones would become a painter – an ambitious venture for one who had never previously painted.

Back in Birmingham, with Morris and others, Burne-Jones planned to start a magazine (ultimately published as the short-lived *Oxford and Cambridge Magazine*) in the spirit of the Pre-Raphaelite Brotherhood's *Germ* – and largely financed by Morris – to express their ideals through selections of poetry, essays and literary criticism. At this time a copy of the poet Robert Southey's 1817 reprint of the first ever printed edition of Malory's *Morte d'Arthur*, originally published in 1485 by William Caxton, was offered for sale in Birmingham. The book exerted perhaps the greatest single influence on Burne-Jones, even though he could not afford to buy it and had to stand in the bookshop reading it (Morris eventually purchased it and loaned the volume to him).

Georgiana Burne-Jones later described the

Dante Gabriel Rossetti photographed by Lewis Carroll.

book's importance to Morris and her husband: 'I think that the book can never have been loved as it was by those two men. With Edward it became literally a part of himself. Its strength and beauty, its mystical religion and noble chivalry of action, the world of lost history and romance in the names of people and places – it was his own birthright upon which he entered.' This, above all, was the root of Burne-Jones's fascination with the mythical Arthurian world and its visionary quest for the unattainable.

Having made his crossroads decision, Burne-Jones began to have serious doubts about continuing at Oxford. His eagerness to start work immediately as painter was tempered by his awareness that, for financial reasons, it was utterly impractical – and he was hesitant about broaching the subject with his father. Morris gained his degree and, true to his vow to become an architect, entered the office of George Edmund Street, the architect of churches and the neo-Gothic Law Courts in London. Burne-Jones left Oxford at Christmas 1855 and, although he later returned, he no longer seriously intended pursuing his degree. January 1856 found him in London where he set himself the task of meeting his hero Rossetti, whose *The Maids of Elfen-Mere* illustrations he had recently seen and had praised in the *Oxford and Cambridge Magazine*. Learning that Rossetti lectured at the Working Men's College in Great Ormond Street, he went there and saw him but did not speak to him; by chance, though, he met Vernon Lushington, who invited him to meet Rossetti at his home soon afterwards. This first encounter led to a visit to Rossetti's studio by Blackfriars Bridge, and a friendship that was to last for more than a quarter of a century. Rossetti, though only five years older than Burne-Jones, immediately adopted him as his pupil, describing him as 'one of the nicest young fellows in Dreamland', a reference to the dreamlike state of mind of most of the idealistic contributors to the *Oxford and Cambridge Magazine*.

Burne-Jones saw progressively more of Rossetti as their master/pupil relationship developed into an informal apprenticeship, although Rossetti's methods were instinctive and far removed from conventional art tuition. Coming to art late in life (Burne-Jones was now aged 24), he

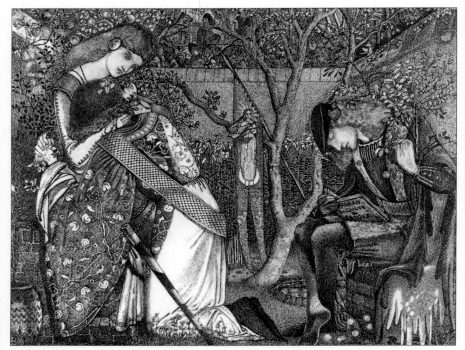

The Knight's Farewell (1858), an early pen and ink drawing once owned by William Morris.

extending to include John Ruskin and the poet Robert Browning.

The practical and pressing requirement for Burne-Jones to earn an income, however modest, could not be ignored, and Rossetti aided him in getting early commissions, including a cartoon for *The Good Shepherd*, a stained glass for James Powell & Son, which was used several years later in a church in Maidstone; this was followed by further stained-glass commissions, such as his *St Frideswide* for Christ Church, Oxford. These were to become Burne-Jones's principal source of income until he had established his reputation and livelihood as a painter, and continued to be his principal ancillary activity throughout his life. While it is significant that this early work should follow the Ruskin and Morris ideal of being available to the public, and not hidden in a private collection, he did not neglect the latter category of work, among which were his first paintings commissioned by a patron, Thomas E. Plint, a Leeds businessman, for two watercolours on the theme of *The Blessed Damozel*. Watercolour was to become one of Burne-Jones's most important mediums: it is known that the odour of turpentine made Burne-Jones nauseous, so throughout his working life he habitually turned to watercolour in preference to, but used almost as thickly as, oil, often mixed with other materials, such as gold, to create jewel-like surfaces.

When in 1857 Rossetti received the commission to decorate the debating hall of the Oxford Union with a series of murals, it was natural that Burne-Jones should be included in the group of associates he took with him: not that it

combined this instruction with attendance at life classes given by the history painter James Matthews Leigh in Newman Street – and, as if to make up for lost time, also enrolled at the same time in two further art classes. The Royal Academy exhibition of that year included *The Scapegoat*, the masterwork of Holman Hunt (who Burne-Jones was to meet in Rossetti's studio), and Arthur Hughes's *April Love* – which Burne-Jones was commissioned to purchase on Morris's behalf. In 1856 Burne-Jones became engaged to the 16-year-old Georgiana Macdonald, whose family was now living in London. According to some accounts, he proposed to her as they stood in front of Hughes's sentimental painting.

Morris moved with Street from Oxford to London (soon afterwards leaving this employment altogether) and shared

Self-caricature of Burne-Jones's Red Lion Square home and studio (1856). He is examining a chair back decorated by Rossetti.

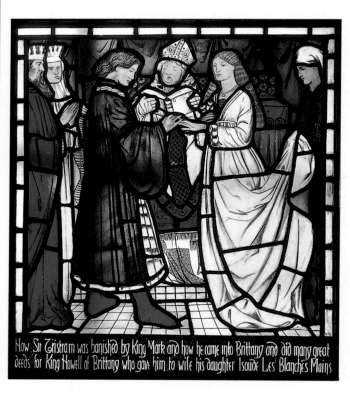

The Wedding of Sir Tristram, a stained-glass window designed by Burne-Jones for the music room at Harden Grange, Bingley (1862).

lodgings with Burne-Jones in Bloomsbury, moving in November 1856 to rooms in Red Lion Square. Burne-Jones' art was to pass through several distinct phases, and his characteristic works from this period were his medieval drawings, such as *The Knight's Farewell*. It was also in Red Lion Square that he undertook his first decorative work, a Chaucerean design painted on a wardrobe. Having met Rossetti, Hughes and Hunt, he now met the other artists in the Pre-Raphaelite circle, Millais and Ford Madox Brown, his widening group of influential acquaintances

was a lucrative commission, since only the costs of the group's materials and accommodation were to be paid, but no fees. A group of scenes from the *Morte d'Arthur* was agreed, and Burne-Jones, Morris, Arthur Hughes and others worked on them for months in a spirit of camaraderie and enthusiasm coupled with chaos and incompetence. This was compounded by the fact that none of them had the least idea of the technique of mural painting. The work, for which Burne-Jones contributed scenes depicting Merlin, was never finished (at least by Rossetti, *et al*), but the trip was not without its lasting effects: it honed Burne-Jones's painting skills and reinforced the would-be muralists' friendship, while during their stint Morris first met Jane Burden, an ostler's daughter, who was recruited as a model — becoming one of the most-painted of all Pre-Raphaelite women. During their Oxford sojourn Burne-Jones grew the beard which he retained for the rest of his life, establishing a distinctive visage that scarcely altered during the ensuing forty years.

Soon after the Oxford enterprise — and this was a common reaction to any unusual or stressful circumstances — he fell ill and was cared for by the family of society hostess Sara Prinsep who he was to describe as 'the nearest thing to a mother I ever knew'. The celebrated painter George Frederick Watts had a studio in her house, and so Burne-Jones saw him at work and was encouraged by Watts to improve his drawing beyond the often slapdash style of Rossetti (apart from these two 'tutors' and occasional attendance at classes, Burne-Jones did not study art in any sense formally, and was thus one of the greatest of all self-taught artists). Upon his recovery he moved to new accommodation near his old rooms in Red Lion Square.

In 1859 Georgiana Macdonald and her large family moved to Manchester, while Burne-Jones set off on a trip to Italy with Sara Prinsep's son Val and a friend, Charles Faulkner, falling under the spell of the paintings he saw in Florence and Venice. Morris married Jane Burden and, on Saturday 9 June 1860, after their four-year engagement, Burne-Jones at last married Georgiana in Manchester. Nervous as ever, their planned joint honeymoon in Paris with Rossetti and Elizabeth Siddal was abandoned when Burne-Jones was taken ill, and Georgiana immediately adopted the role she was to endure for almost forty years, that of Burne-Jones's nurse.

For his patron James Leathart, Burne-Jones produced the two watercolours *Sidonia von Bork* and *Clara von Bork*, but was nevertheless constantly plagued by money worries.

Georgiana Burne-Jones and Jane Morris soon became pregnant. Elizabeth Siddal gave birth to a child that died, and she herself died the following year after taking an overdose of laudanum. Rossetti buried a book containing his unpublished poems in her coffin, later macabrely arranging for her body to be exhumed to recover them. After these traumas he became increasingly reclusive and, though they continued to see each other occasionally, gradually faded from Burne-Jones's life, dying in 1882.

Morris, Marshall, Faulkner & Co, William Morris's company, was inaugurated in 1861, providing commissions for his closest associates, among them Burne-Jones, Rossetti, Brown and Philip Webb, who had designed Morris's Red House in Kent, which Burne-Jones and others of the group had had a hand in decorating. They were to devote themselves to creating decorative work in such areas as furniture, pottery, tiles, textiles and stained glass — the latter becoming increasingly Burne-Jones's special forte. Burne-Jones's son Philip was born in October 1861, and the following May he and Georgiana left the baby with her family and set off to accompany Ruskin to Italy on a conservation trip, copying paintings threatened with decay. In 1864 Burne-Jones was elected an Associate of the Old Water-Colour Society, against the better judgement of some of its venerable members to whom he represented the unacceptable face of the new. At an exhibition that followed his election, his works *The Merciful Knight* and *Annunciation* were severely criticized, yet he was not unappreciated among a select following. He steadily acquired further patrons, among them Frederick Leyland, a shipowner, who became the owner of a number of his works (and for whom Burne-Jones eventually designed his 'Arts and Crafts' tomb in Brompton Cemetery, London), William Graham, Liberal MP for Glasgow, and George Howard, later Earl of Carlisle, himself an accomplished artist.

Burne-Jones painted his first version of *Green Summer* at Morris's Red House in Kent, which became the country retreat of members of his circle. Morris proposed to extend the house to enable the Burne-Jones family to live there and to open a guild workshop on the premises, but, unable to meet the cost of the conversion, the plan was abandoned. Edward and Georgiana's second child, Christopher, was born but died soon afterwards, and the family moved to a rented house in Kensington Square, furnishing their new home with Morris fabrics and furniture. Morris's

St Martin, a design for stained glass, one of Burne-Jones's preoccupations throughout his working life.

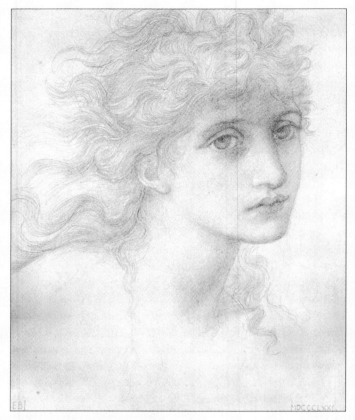

Burne-Jones's
sensitive pencil
portrait of Maria
Zambaco (1871).

firm received a series of important commissions, including the dining room at the Victoria & Albert (then South Kensington) Museum for which Burne-Jones executed the windows and panels depicting the signs of the zodiac. He also began a series of illustrations for Morris's epic poem, *The Earthly Paradise*, Morris himself undertaking the woodcuts. A long-term project, it was many years before the final result was achieved.

A daughter, Margaret, was born in June 1866, and the following August Georgiana's sister Aggie married the painter Edward Poynter in a double wedding with her sister Louie, who married Alfred Baldwin (their son, Stanley Baldwin, became prime minister in 1923); another sister, Alice, and her husband John Lockwood Kipling were the parents of Rudyard Kipling.

Burne-Jones made the acquaintance of the wealthy expatriate Greek family, the Ionides. They became important patrons and through them he was introduced to Mary Zambaco, *née* Cassavetti. A beautiful 'stunner' (in the jargon of the Pre-Raphaelite circle) for whom the cliché 'flame-haired temptress' might have been invented, she had married a Dr Demetrius Zambaco by whom she had two children, but left him in Paris and moved to London. Her relationship with Burne-Jones began when her family commissioned her portrait, and she soon became his favourite model. Although he made extensive use of the professional Italian and Greek models resident in London and shared certain models with other Pre-Raphaelites, among them Rossetti's Fanny Cornforth, he also painted many friends and members of his family: Georgiana appears in a number of works, as, later, do his children, including Margaret in the *Briar Rose* paintings, and members of the Morris family. Maria Zambaco, however, became more than a sitter and more than a model; she

became his ultimate muse and inspiration as he rapidly became obsessed with her and an intense affair began.

He and Georgiana spent the summer of 1867 near Oxford with friends, but while they were away their Kensington Square house was sold. They duly moved to Fulham, now a western suburb of London but at the time virtually in the countryside. The Grange, the house they now occupied, was the large but run-down mansion where, in the 1740s, Samuel Richardson had written *Pamela* and *Clarissa*. Within hours of their housewarming party, the ceiling collapsed, showering Burne-Jones's studio with plaster and ruining the work he had on display.

His liaison with Maria Zambaco blossomed, but was ultimately disastrous: she threatened suicide and his marriage almost broke up. Burne-Jones was horrified by the powerful emotions released by his affair: 'Lust' (as he was later to comment in connection with the images depicted in Aubrey Beardsley's drawings) 'does frighten me. I say it looks like such despair – despair of any happiness and search for it in new degradation.' After it was finally over, he continued to maintain close relationships with many women friends, particularly Frances Horner, *née* Graham, the daughter of his patron William Graham, to whom he wrote many passionate letters. Meanwhile, Georgiana became friendly with the novelist George Eliot and sought her company as a sympathetic confidante. It seems likely that Edward's subsequent affairs were platonic, but his domestic life was never again as happy as it had been: he and Georgiana had no more children and increasingly led separate lives and pursued their own interests, she devoting herself to charitable causes and community activities.

Yet out of his tormented affair great works had emerged: *Evening Star*, *Night* and *Phyllis and Demophöon*,

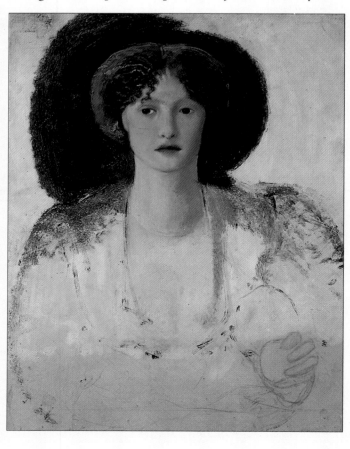

Study for *Hope*, one of Burne-Jones's 'Venetian' paintings of the 1860s.

three works shown at the Old Water-Colour Society in April 1870, are typical of many superb subjects featuring Maria Zambaco that date from this troubled period, the last among them leading to controversy. His affair with Maria Zambaco was an open secret in the artistic community, but here she was being flaunted naked to public gaze. Whether for this reason, or simply because the nudity of the figures depicted in it had resulted in public complaints, as it was alleged, he was asked to remove the picture from the Society's walls. While he calmly acceded to this

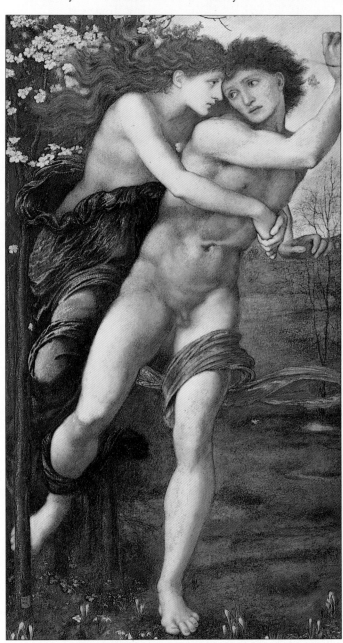

The nudity of *Phyllis and Demophöon* (1870) led to its withdrawal from exhibition.

request, he was untactfully requested to choose an innocuous picture by another artist in its place. In response, he refused and resigned from the Society.

In the same year as this scandal took place, Burne-Jones's portrait was painted by Watts, and he fell under the older artist's influence, to the extent that their works of this period have close affinities. In 1871, the year in which William Morris began renting Kelmscott Manor, Burne-Jones travelled to Italy, visiting the country again with Morris in 1873. Increasingly, the paintings of the

great Italian masters began to exert their influence in his works.

Burne-Jones's wide network of friends included actresses Ellen Terry and Mrs Patrick Campbell, writers Oscar Wilde, Robert Louis Stevenson and Henry James, who was to describe Burne-Jones's work as the 'art of culture, of reflection, of intellectual luxury'. He was also close to fellow artists such as Leighton and Alma-Tadema, whose work, perhaps surprisingly, he greatly admired, and who introduced him to Jules Bastien-Lepage (who painted Burne-Jones's portrait), and he was also familiar with and an admirer of James Tissot. It was at The Grange that the young illustrator Aubrey Beardsley first met Oscar Wilde, later illustrating his celebrated *Salome*. His circle also extended into the political arena, to Mary Gladstone, the daughter of prime minister William Gladstone, and Arthur Balfour (later prime minister), who ordered paintings for his music room, which resulted in the *Perseus* series (the unfinished oil set in Stuttgart, with full-sized studies in Southampton).

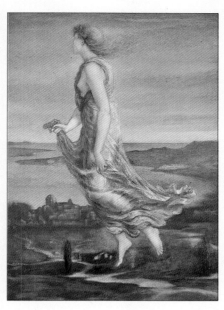

Evening Star (1870), an ethereal image modelled by Maria Zambaco.

Appreciative patrons such as Balfour generally gave him full rein and the lack of importance he attached to public approbation meant that he could afford to be uncompromising in his choice of subjects. Certain themes continued to obsess Burne-Jones throughout his working life; a recent biographer, Penelope Fitzgerald, comprehensively summarized them as: 'The enchantment of the willing victim, sleep, waiting, imprisonment, loneliness, guiding, rescue, the quest, losing and finding, tending the helpless, flying, sea-crossing, clinging together, the ritual procession and dance, love dominant and without pity, the haunting angel, the entry into life.' He returned to these motifs time and time again, painting the same subjects repeatedly, often producing an oil version of a watercolour or vice versa, or painting versions of subjects that he had originally designed as tapestries or stained glass.

Despite his disinterest in public shows of his work, he was persuaded in 1877 to exhibit at the newly-opened Grosvenor Gallery alongside works by Alma-Tadema, Millais, Leighton and Whistler, representatives of the varied schools that co-existed at the time. Ruskin's criticisms of Whistler's displayed work resulted in a celebrated libel case (which Whistler won, but was bankrupted as a result). Much to his chagrin and embarrassment, Burne-Jones was called as a witness on Ruskin's side in the case. His work was considered characteristic of the first stirrings of the Aesthetic Movement, and publicity from

John Ruskin's support of Burne-Jones was reciprocated when he acted as a witness in the Whistler *v* Ruskin libel case.

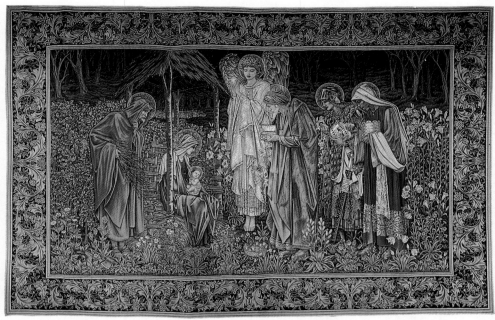

The Adoration of the Magi, a tapestry version of Burne-Jones's large watercolour, *The Star of Bethlehem*.

this supposed association, coupled with the wider exhibition of his works and reproductions through engravings, led to an almost overnight surge in Burne-Jones's popularity. His work became much copied and emulated, and his *Golden Stairs* was satirized in Gilbert and Sullivan's comic opera *Patience*.

Burne-Jones appears to have been genuinely disinterested in criticism of his work, and retained his sense of humour: when the potter William de Morgan asked if he was starting a new painting, he answered in the style of a critic, 'Yes, I am going to cover that canvas with flagrant violations of perspective and drawing and crude inharmonious colour.' Despite his disregard for the opinion of others, his shunning of the established routes followed by many of his contemporaries (such as exhibiting at the Royal Academy), and determined pursuit of his own distinctive style of painting during the 1880s and 1890s, Burne-Jones's

Houses at Rottingdean, the Burne-Jones family's country home from 1880 onwards.

renown steadily grew until, in his last years, he was widely regarded as Britain's greatest living artist.

The final years of Burne-Jones's life were occupied by his ongoing paintings – and one in particular. As a retreat from London, the Burne-Joneses bought Prospect House in Rottingdean, on the Sussex coast, later purchasing next-door North End House and connecting them. There, after it was transported from a studio in Campden Hill Road, London, he devoted many years to *The Last Sleep of Arthur in Avalon*, originally commissioned by George Howard. It measured a vast 21 feet (6.5 metres) long – half the size

of a tennis court. Many of his paintings were conceived on a colossal scale (unlike those of his friend Alma-Tadema, whose works, though crowded with detail, often surprise by their small scale). Their size and his prolific output, with numerous works in progress at any one time, meant that he was compelled to employ studio assistants, among them Charles Fairfax Murray and Thomas Rooke. The range of Burne-Jones's work is also impressive. As well as paintings and designs for stained glass, he created numerous portraits, book illustrations, decorative work such as the famous Graham piano, the mosaic for the American Episcopal church in Rome, completed after his death, and theatre sets for a production of *King Arthur* at London's Lyceum Theatre.

In 1885 – and much to his surprise – he was elected an Associate of the Royal Academy. As with his earlier membership of the Old Water-Colour Society, he was ill at

Edward Burne-Jones and his granddaughter Angela, later Angela Thirkell, (c.1893).

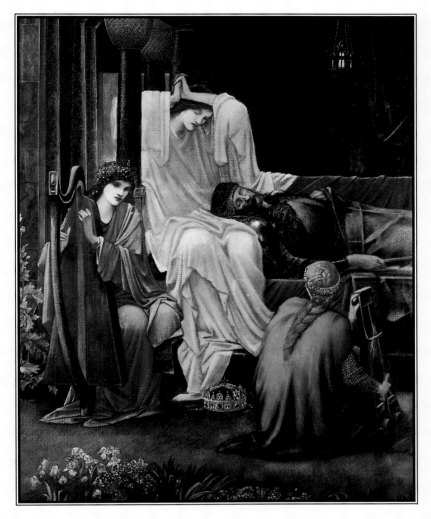

Detail from *The Last Sleep of Arthur in Avalon* (1881–98), the gigantic painting that he intended as the culmination of his life's work.

ease with the organization and resigned a few years later, having only once exhibited at the Academy. With Watts and Alma-Tadema he became one of the principal exhibitors at the New Gallery, opened in 1888. In the same year, to commemorate the marriage of his much-loved daughter Margaret to the classical scholar John W. Mackail in, appropriately, St Margaret's church, Rottingdean, Burne-Jones created a three-light stained-glass window depicting the archangels Gabriel, Michael and Raphael. In 1890 Margaret had a daughter who grew up to become the novelist Angela Thirkell.

The Paris Exposition Universelle of 1889 had led to Burne-Jones's discovery by French Symbolists and a wave of public interest in France. He devoted himself to his work on Kelmscott Press illustrations with Morris, starting with *Chaucer*, the resulting book containing 87 illustrations by Burne-Jones. In 1894 he was offered a baronetcy by Gladstone 'in recognition of the high position which you have obtained by your achievement in your noble art.' When he died, suddenly, on 17 June 1898, such was his fame that his was the first ever memorial service for an artist held in Westminster Abbey. His ashes were buried at Rottingdean, in a niche in the wall in sight of North End House, to

where Georgiana retired, with her nephew Rudyard Kipling living in the house opposite.

Burne-Jones was fortunate indeed to have had the enduring support of his wife Georgiana, who tolerated his moods and behaviour as he embarked on one infatuation after another. In fact, her love for him extended beyond their life together. After his death, she diligently assembled the materials to compile a substantial two-volume biography of her husband, *Memorials of Edward Burne-Jones* (1904). It would have been a challenge for any writer: since he detested the idea of his biography being written, he had systematically destroyed most of the letters he had ever received, asked correspondents to burn his to them (though few actually did so) and even scoured auctions for any he had written that might be offered for sale. Georgiana was not an experienced writer and the result could have been a disaster. In fact, it was a triumph: barring the total lack of references to his indiscretions (Maria Zambaco is not even mentioned), it is one of the most accurate, warm and sensitive accounts of an artist's life ever written.

The first page of the magnificent Kelmscott *Chaucer* (1896), one of the finest results of the collaboration between Burne-Jones and William Morris.

Many of his contemporaries also thought fit to include reminiscences of Burne-Jones in their autobiographies,

Portrait of Katie Lewis (1882). She is shown reading the story of St George and the Dragon.

friend and lawyer, George Lewis, written in 1883 and later published. Intolerant of bores and frivolous time-wasters and shy in unfamiliar company, he often hid when visitors came to see his paintings. Although quiet in his manners, he had occasional flares of violent temper: once, using a red-hot poker, he burned a hole through a book to which he had taken exception. His generosity was widely noted: once he was able to afford to do so he supported his father and old nanny Mrs Sampson, and loaned money to Constance Wilde when Oscar Wilde was jailed. He was also actively involved in encouraging the nation to acquire and preserve art treasures.

while the studio diary kept by his assistant Thomas Rooke has even preserved virtually verbatim conversations with the 'master'. From such accounts have emerged an impression of Burne-Jones the man. His customary greeting, which endeared him to his friends, was, 'Are you happy?' Mostly, he was not. His was a withdrawn, introspective and in many ways depressive personality. Highly strung and sensitive, there are many descriptions of his collapse under stress, and of a life wracked with anxieties, hypochondria and pessimism. Yet for all his gloom, he could, as all who knew him testified, emerge to become the most charming company. He evidently enjoyed bohemian male companionship, dining, smoking old clay pipes and playing practical jokes with his cronies. His sense of humour was legendary. One of his favourite devices was massive exaggeration for dramatic effect: in a letter he told of visiting 2,845 houses in the search for his Chelsea flat, and once told Gladstone that precisely 801,926 birds nested in a particular tree in his garden. He took to calculating his age according to how he felt, thus in 1888 he reckoned he was 97, and in 1893 variously 175 and 485. He was an eloquent and witty speaker and a writer with a true artist's sense of imagery, for example describing the black-draped coffin borne aloft by six pall-bearers at Browning's funeral as resembling a beetle. Throughout his life he produced comic sketches and caricatures, and he was famed for his ability to entertain children: his letter-writing, art and humour all coalesced in his *Letters to Katie*, a collection of his illustrated letters to Katie Lewis, the daughter of his

Burne-Jones's paintings, especially those from the later phase of his 40-year career, possess an irresistibly dream-like and often mysterious and detached quality, while he displayed a technical virtuosity unmatched by his rivals and the many followers he influenced. Cumulatively, these attributes meant that Burne-Jones was one of the most admired painters both in his own century and in our own. His art was a highly personal interpretation of Pre-Raphaelitism, and it is perhaps the uniqueness of his own imagination that makes his paintings so significantly different from those of his contemporaries. His artistic life was a continual pursuit of beauty, an obsession with battles fought and choices made between good and evil, with chivalry and courtly love, all intricately interwoven with High Victorian ideals, yet rejecting Victorian materialism. His sense of beauty was one that was never diluted with ugliness, once writing, 'Only this is true, that beauty is very beautiful, and softens, and comforts, and inspires, and rouses, and lifts up, and never fails.' Lord David Cecil saw him as 'A highly civilized aesthete, born in an uncongenial period of material progress, philistine taste and religious doubt. He lived for beauty, but saw it as something alien, remote, out of reach' as he confronted the problem of being 'a poetic artist in a prosaic age' — a *fin de siècle* mentality that is not without its echoes as we ourselves approach the end of another century.

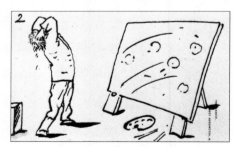
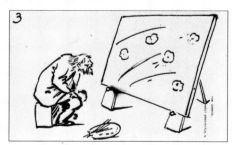

Burne-Jones's letters to Katie Lewis contain this sequence of caricatures in which he tries unsuccessfully to enter the imaginary world of his *Briar Rose* paintings, signing himself with a pictorial 'Mr Beak', Katie's nickname for him.

THE PLATES

1. SIDONIA VON BORK

2. ASTROLOGIA

3. THE PRINCESS SABRA LED TO THE DRAGON

4. GREEN SUMMER

5. SPRING *AND* AUTUMN

6. DAY *AND* NIGHT

7. PORTRAIT OF MARIA ZAMBACO

8. TEMPERANTIA

9. PAN AND PSYCHE

10. THE BEGUILING OF MERLIN

11. THE LAST JUDGEMENT

12. THE DAYS OF CREATION – THE FIFTH *AND* SIXTH DAYS

13. LE CHANT D'AMOUR

14. THE MIRROR OF VENUS

15. PYGMALION AND THE IMAGE – THE GODHEAD FIRES

16. PYGMALION AND THE IMAGE – THE SOUL ATTAINS

17. LAUS VENERIS

18. THE ANNUNCIATION

19. THE GOLDEN STAIRS

20. THE MILL

21. THE HOURS

22. TREE OF FORGIVENESS

23. THE WHEEL OF FORTUNE

24. KING COPHETUA AND THE BEGGAR MAID

25. SIBYLLA DELPHICA

26. THE DEPTHS OF THE SEA

27. THE ARMING OF PERSEUS

28. THE ROCK OF DOOM

29. THE BALEFUL HEAD

30. DANAE AND THE BRAZEN TOWER

31. THE BRIAR ROSE – THE PRINCE ENTERS THE BRIAR WOOD

32. THE BRIAR ROSE – THE SLEEPING PRINCESS

33. THE STAR OF BETHLEHEM

34. SPONSA DE LIBANO

35. VESPERTINA QUIES

36. LOVE AMONG THE RUINS

37. ANGELI LAUDANTES

38. THE WEDDING OF PSYCHE

39. LOVE LEADING THE PILGRIM

40. THE PRIORESS'S TALE

NOTES

Burne-Jones frequently worked on his paintings over very long periods, sometimes spanning many years.
Both the commencement and completion years are given where known, and the plates are arranged
in chronological order of completion.
Oil: oil on canvas.
Watercolour/gouache: watercolour/gouache on paper, unless otherwise stated.

PLATE 1

SIDONIA VON BORK
---- 1860 ----
Gouache, 13.0 x 6.7 in / 33 x 17 cm
Tate Gallery, London

Completed just prior to Burne-Jones's marriage to Georgiana, this painting and its companion, *Clara von Bork*, are derived from the story of *Sidonia the Sorceress* by the German author Johann Wilhelm Meinhold. Translated into English in 1849 by Oscar Wilde's mother, Lady Jane Wilde (known as 'Speranza'), it is a chronicle of a noblewoman who in 1620, at the age of 80, was put to death for witchcraft. Her evil combined with her beauty and the mysterious occult element appealed to the Pre-Raphaelite imagination; *Sidonia* was a favourite book of Rossetti's and William Morris issued a reprint of it under his Kelmscott Press imprint in 1893. In the painting the Duchess of Wolgast appears in the background, while Sidonia herself is seen plotting some new crime.

The inscription 'Sidonia von Bork 1560' appears on the mount, thus indicating that Burne-Jones considered her to be aged 20 in the picture. It was one of his earliest watercolours and was possibly modelled by Rossetti's mistress Fanny Cornforth. The marvellously intricate design of the dress is said to have been based on a portrait of Isabella d'Este at Hampton Court where the royal galleries had been opened to the public in 1830 and were customarily visited by groups from art schools; Burne-Jones is known to have gone there to see the Raphael cartoons. The elaborate hairstyle comes from Meinhold's own description of a fictitious portrait of Sidonia by Lucas Cranach. The work and the accompanying *Clara*, which deals with Sidonia's virtuous cousin by marriage, were framed by Burne-Jones's father before being sent at Christmas 1860 to James Leathart of Newcastle. A replica of *Sidonia* (now in a private collection) was produced for Thomas E. Plint, another important patron of his early years.

PLATE 2

ASTROLOGIA
—— 1865 ——
Gouache, 21.5 x 18.3 in / 54.5 x 46.5 cm
Private collection

In 1862 Edward and Georgiana Burne-Jones visited Italy, where he was employed by Ruskin in copying crumbling works by Venetian masters, including Paolo Veronese and Jacopo Tintoretto. Ruskin clearly selected the paintings as important not only as visual records but in aiding Burne-Jones's own development as an artist, and the trip undoubtedly had a considerable influence. *Hope* (collection of the Duke of Wellington), a 'Venetian half-length' portrait, dating from 1862, was the first obvious result, and, like *Astrologia*, also contains an image of globe, while the sphere motif reappears in further works, such as the *Days of Creation* series (Plate 12) and even became a studio prop that featured in portraits, such as that of the Baronne Deslandes (1898).

Astrologia was modelled by Augusta Jones, who appears in *The King's Daughter* (1865–66; Musée d'Orsay, Paris). The esoteric symbols in the ancient manuscript that the subject examines hark back to Burne-Jones's own studies of medieval literature during his years at Oxford University. The picture was exhibited at the Old Water-Colour Society in 1865, at the New Gallery in 1892, and again in the memorial exhibition of 1898.

The characteristic richness of Burne-Jones's watercolours is often surprising, and is partly explained by his use of techniques that were opposed to those of the medium with which he was working. As the portrait painter and illustrator W. Graham Robertson (1867–1948), a young admirer and friend of Burne-Jones, later explained: 'In water-colour he would take no advantage of its transparency, but load on body colour and paint thickly in gouache; when he turned to oil he would shun the richness of impasto, drawing thin glazes of colour over careful drawings in raw umber heightened with white.'

The Princess Sabra Led to the Dragon

—— 1866 ——

Oil, 42.5 x 38 in / 108 x 96.6 cm
Private collection

The artist Myles Birket Foster commissioned Burne-Jones to produce seven pictures on the theme of St George and the Dragon, of which this is one. It represents the legend of St George, a Roman tribune from Cappadocia, who went to Silene in Libya where a dragon was terrorizing the town, demanding young women be sent to it as sacrifices. When it was the turn of the king's daughter, Princess Sabra, to be sacrificed, she was rescued by St George who agreed to slay the dragon if the king and his subjects would convert to Christianity. Foster ordered the paintings for the dining room of his Tudor-style house, The Hill, at Whitley in Surrey, which he had designed himself in 1863 and had decorated by the newly-established firm of Morris, Marshall, Faulkner & Co. These were among the first pictures on which Burne-Jones's talented studio assistant Charles Fairfax Murray was employed. After Foster left the house, the St George paintings came up for sale in 1894. The following year Burne-Jones undertook some restoration work to the set and it was exhibited in 1897, winning the gold medal at the Munich International Exhibition, and again at his memorial exhibition. The series, which has since been widely dispersed, includes *The Return of the Princess* (Bristol City Art Gallery), *The King's Daughter* (Musée d'Orsay, Paris) and *St George Kills the Dragon* (Art Gallery of New South Wales, Sydney), with studies in Birmingham City Art Gallery and the British Museum.

GREEN SUMMER
—————— 1868 ——————
Oil, 25.5 x 41.8 in / 64.7 x 106.1 cm
Private collection

Burne-Jones began his first version of this work in watercolour in May 1864 at William Morris's Red House at Upton in Kent. It features eight young women, with Georgiana in black reading to the others, and her sister Louie and Jane Morris (holding peacock feathers, a symbol of the month of May) in the centre. The work, studies of which exist in Birmingham City Art Gallery and in the Ashmolean Museum, Oxford, was undertaken in the Red House studio — not, as might be supposed, in the garden itself. Burne-Jones was opposed to the Impressionist technique of painting from nature and seldom worked out of doors except for sketching occasional backgrounds to be incorporated into studio works. Also, according to W. Graham Robertson, he never expressed 'pleasure at a natural effect except when it reminded him of a picture or a story.'

Green Summer was exhibited in 1865 at the Old Water-Colour Society, the body to which he had been elected the previous year. The *Art Journal* critic was perplexed by this 'harmony in green', querying, 'Why is it that he has woven the robes of the picnic party of the green grass whereon they sit, thus bidding defiance to known laws of chromatic art, which are now established with the certainty of scientific axioms?' This later oil dates from 1868 when it was acquired by Burne-Jones's patron William Graham. For Burne-Jones it is an unusual scene, bearing comparison with works by Giorgione, but with affinities to such contemporary paintings as Millais' *Apple Blossoms* of 1859 (Lady Lever Art Gallery, Port Sunlight), which similarly features eight girls, and Tissot's *Le Printemps* of 1865 (private collection). It may be viewed simply as a memoir of a happy summer in the country, lacking any obvious literary origin. However, two possible sources of inspiration have been suggested: Burne-Jones was on close terms with Algernon Swinburne, whose 'In the Orchard', published in his *Poems and Ballads*, 1860, contains the lines:

> The grass is thick and cool, it lets us lie.
> Kissed upon either cheek and either eye,
> I turned to thee as some green afternoon
> Turns toward sunset, and is loth to die.

Perhaps more significantly, Burne-Jones's beloved *Morte d'Arthur* observes how winter 'doth always erase and deface green summer', which it compares with the transient nature of the love between man and woman. In 1979 this work was sold for the then record price of £48,000, marking the beginning of the sharp escalation in the value of Burne-Jones's paintings that continued during the 1980s.

PLATE 5

SPRING *AND* AUTUMN
——————— 1869–70 ———————
Gouache, 48.2 x 17.7 in / 122.5 x 45 cm
Private collection

Burne-Jones's 'Four Seasons' were painted as part of a commission
for the dining room of the house at 49 Prince's Gate, London, of his
patron the Liverpool shipowner Frederick Leyland. In a letter Burne-
Jones told Leyland, 'I hope you will eat and drink with friends in
their company for fifty years to come,' but his wish was thwarted
when as part of the Aesthetic interior design Whistler's famed
'Peacock Room' was created in the house (1876–77) and the *Seasons*
were moved to another location, eventually being sold at Leyland's
death in 1892.

The paintings, with *Day* and *Night*, are similar in many respects to
the Aesthetic compositions on the same subjects by Albert Moore,
another artist whose work Leyland collected. The colours chosen
were deemed appropriate for each season, as the critic for the
Athenaeum wrote: '*Spring* is represented by a damsel in fresh green
robes . . . *Autumn*, the third member of the group of painted alle-
gories, is of graver character than her sisters, standing before us and
clad in a robe of deep crimson, the colour of the vintage season,
lined with blue, the colour of the declining year.' Maria Zambaco,
whose affair with Burne-Jones was waning, was the model for
Summer. Poems by William Morris were added beneath each painting:

> Spring am I, too soft of heart
> Much to speak ere I depart;
> Ask the Summer-tide to prove
> The abundance of my love.
>
> Laden Autumn here I stand,
> Worn of heart, and weak of hand,
> Nought but rest seems good to me,
> Speak the word that sets me free!

The series was sold as recently as 1965 for only £65 – although it
fetched $37,800 when it was re-sold in 1973.

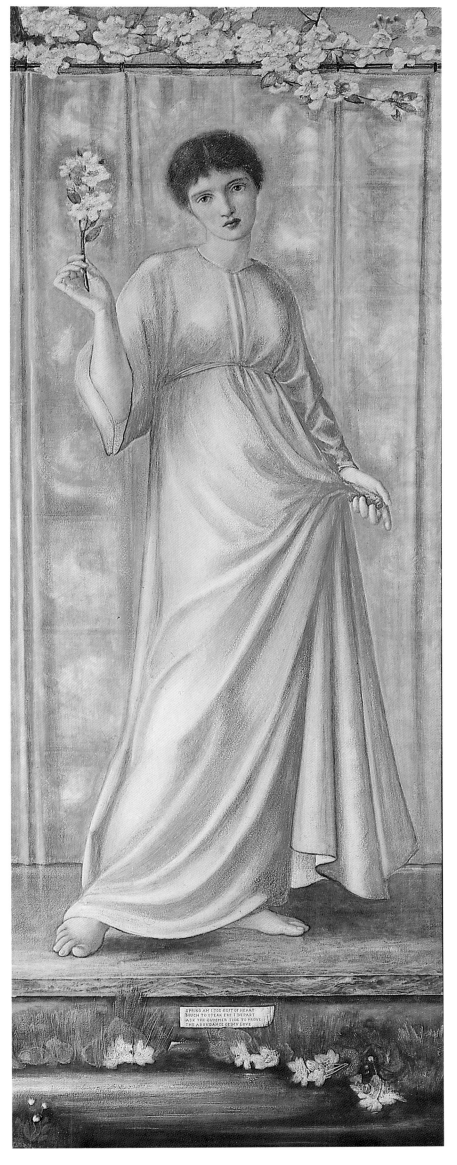

SPRING AM I TOO SOFT OF HEART
MUCH TO SPEAK ERE I DEPART
ASK THE SUMMER TIDE TO PROVE
THE ABUNDANCE OF MY LOVE

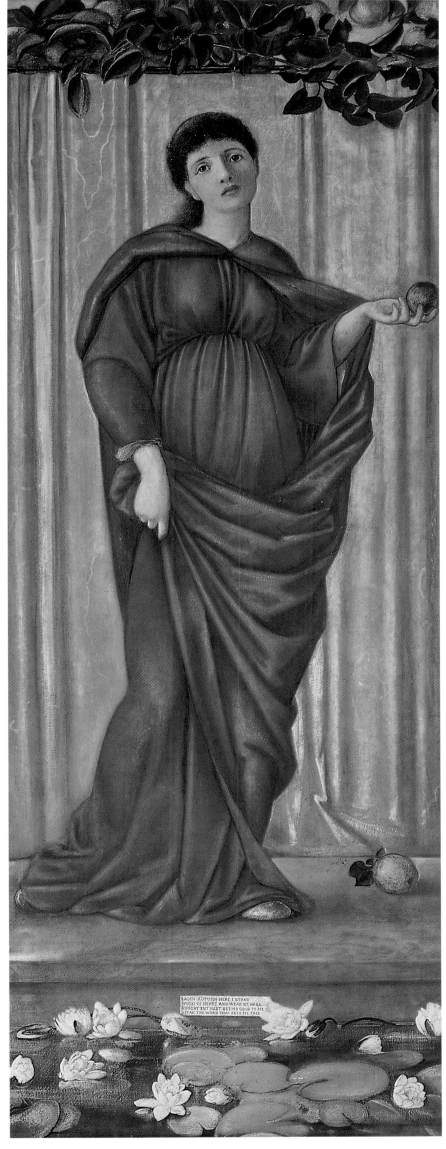

LADEN AUTUMN HERE I STAND
WORN OF HEART AND WEAK OF HAND
NOUGHT BUT REST SEEMS GOOD TO ME
SPEAK THE WORD THAT SETS ME FREE

DAY AND NIGHT
——— 1870 ———
Watercolour and gouache, 47.5 x 17.5 in / 120.7 x 44.4 cm
The Fogg Art Museum, Harvard University, Cambridge, Massachusetts
Bequest of Grenville L. Winthrop

Produced as companion paintings to his 'Four Seasons' for Frederick Leyland's dining room, the blazing torch of *Day* and welcoming open door is contrasted with *Night* – modelled by a blue-clad Maria Zambaco – extinguishing her torch as she closes the door. The latter painting was one of five Burne-Jones exhibited at the Old Water-Colour Society in 1870. The accompanying poems by William Morris were:

> I am Day, I bring again
> Life and glory, love and pain,
> Awake, arise from death to death,
> From me the world's tale quickeneth.
>
> I am Night and bring again
> Hope of pleasure, rest from pain,
> Thoughts unsaid 'twixt life and death,
> My fruitful silence quickeneth.

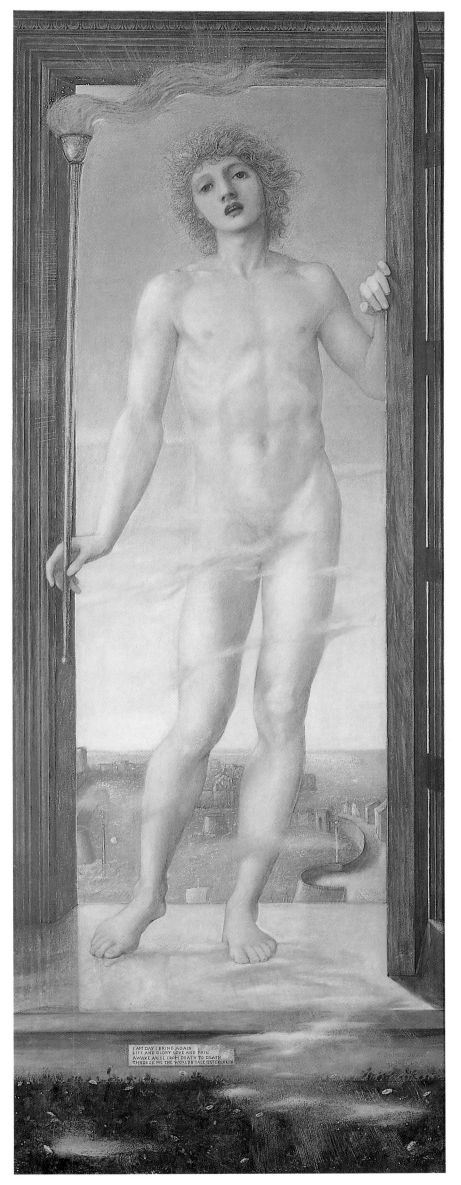

I AM DAY I BRING AGAIN
LIFE AND GLORY LOVE AND PAIN
AWAKE ARISE FROM DEATH TO DEATH
THROUGH ME THE WORLDS TALE QUICKENTH

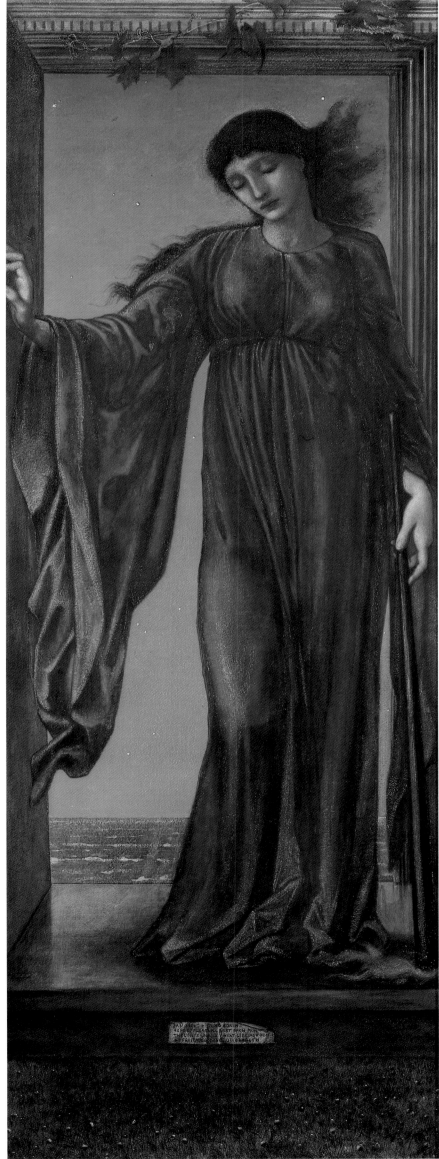

I AM NIGHT I BRING AGAIN
HOPE OF PLEASURE REST FROM PAIN
THOUGHTS UNSPOKEN TWIXT LIFE AND DEATH
MY FRUITFUL SILENCE QUICKENTH

PORTRAIT OF MARIA ZAMBACO
———————— 1870 ————————
Gouache, 30 x 21.7 in / 76.3 x 55 cm
Clemens-Sels-Museum, Neuss

Maria Theresa Zambaco, *née* Cassavetti, a cousin of Constantine Alexander Ionides, one of Burne-Jones's important patrons, began her affair with Burne-Jones in 1867. It proved stormy and by 23 January 1869 Rossetti was writing to Ford Madox Brown to inform him, 'poor old Ned's affairs have come to a smash all together'. The reference is to a series of incidents: following her attempted suicide in the Regent's Canal, Maria and Burne-Jones ran off together, but he was taken ill at Dover, en route for France (just as had befallen him on his honeymoon), after which he returned to Georgiana. Despite this crisis, the affair continued during the next few years, until Maria finally accepted that he was never going to leave his wife.

This very personal portrait shows Maria with Cupid and his arrow, the message attached to which reads, '*Mary Aetat XXVI* [aged 26] *August 7th 1870 EBJ pinxit*'. She holds a medieval manuscript which contains a miniature painting of his *Chant d'Amour* (Plate 13), emphasizing the ambiguity of the pleasure and pain of his relationship with the sitter. Following its sale by the Cassavetti family, the portrait was acquired by the Clemens-Sels-Museum, Neuss, Germany (the only German public collection other than Stuttgart containing Burne-Jones paintings), which additionally owns a pastel portrait of Maria by Rossetti, also dating from 1870.

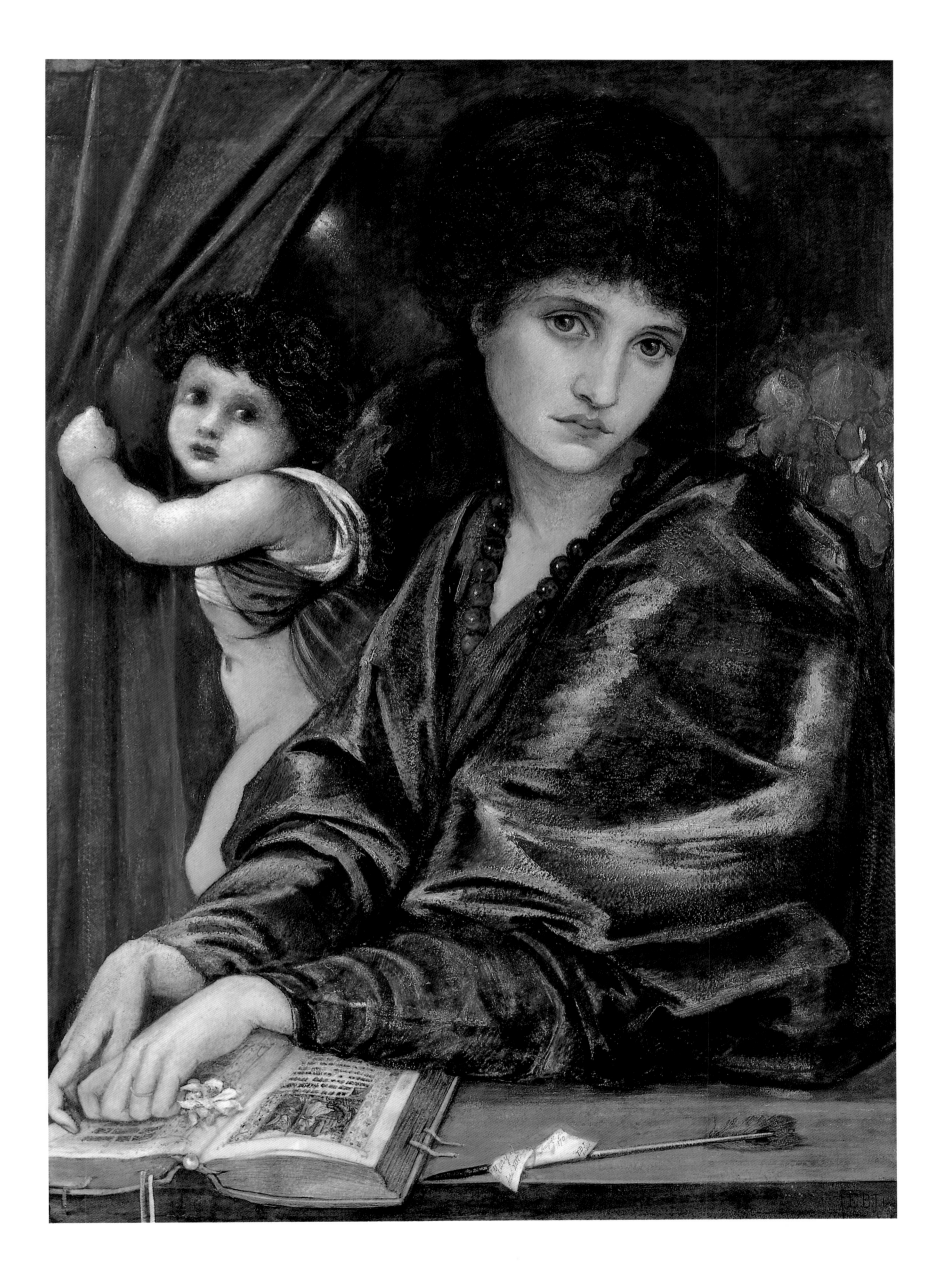

TEMPERANTIA

—— 1872 ——

Watercolour, 60 x 23 in / 152.4 x 58.4 cm
Private collection

The year 1872, in which Burne-Jones finished this allegorical repre-
sentation of Temperance, was particularly prolific. *Temperantia*, a
companion painting to *Fides* and *Spes* (Faith and Hope) from the same
year, was described by Malcolm Bell as depicting 'a stately woman
pouring water from a large jar upon the flames, on which she also
tramples with unharmed feet, in which the artist for the first time
made use of those elaborately folded and wrinkled draperies which
are so characteristic of much of his later work.'

Temperantia is one of Burne-Jones's typical elongated subjects that
clearly derive from his designs for stained-glass windows, the output
of which increased steadily in response to the expansion of church
building and restoration in Victorian England. It was commissioned
with other works by Frederick Startridge Ellis, a bookseller and
author. Ellis, a leading authority on Percy Bysshe Shelley, edited
Kelmscott Press books for William Morris and himself published
works by both Morris and Rossetti. Burne-Jones wrote to Ellis to
inform him, '*Temperance* is nearly finished, and has taken much longer
than *Faith* – God who rules these matters knows why.' All three
were shown with five others at the inaugural exhibition of the
Grosvenor Gallery in 1877.

One of his last identifiable pictures of Maria Zambaco, it can be
read symbolically as an image of Maria finally extinguishing the
flames of their passion. Her subsequent life remains mysterious. She
appears elusively in other work, including stained-glass designs, and it
is known that after living in Paris she returned to London where she
became a sculptress, at one time occupying a studio next door to
Burne-Jones.

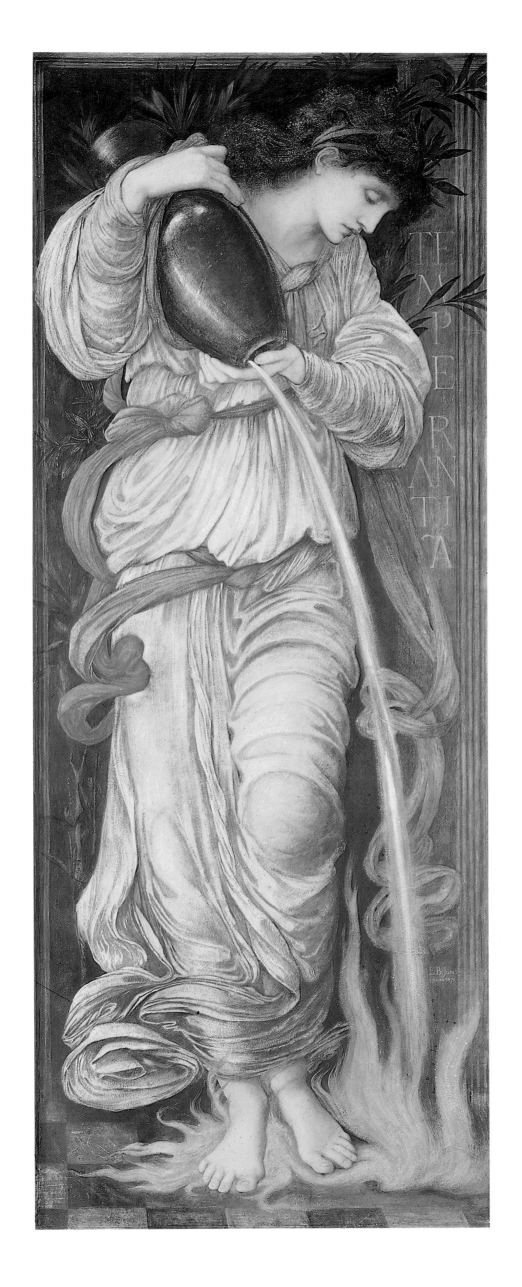

PAN AND PSYCHE
———————— 1872 – 74 ————————
Oil, 25.6 x 21.4 in / 65.1 x 54.3 cm
The Fogg Art Museum, Harvard University, Cambridge, Massachusetts
Bequest of Grenville L. Winthrop

In a letter Burne-Jones presented a personal view of his work: 'I mean by a picture a beautiful, romantic dream of something that never was, never will be – in a light better than any lights that ever shone – in a land no one can define or remember, only desire – and the forms divinely beautiful – and then I wake up.' *Pan and Psyche* belongs to his developing obsession with legendary incidents occurring in dream-like landscapes, in this instance the story of Psyche and Cupid as told in Apuleius's *The Golden Ass* and elsewhere in classical literature. Burne-Jones embarked on the theme in 1864 in illustrations for Morris's *The Earthly Paradise*, but the oil painting was originally conceived in 1869. This was around the time that Maria Zambaco threatened to commit suicide by drowning herself, and there are obvious parallels as Psyche, in despair at being abandoned by Cupid, fails to drown herself and is consoled by Pan. The figure of Pan, half man, half goat, is closely based on a mythological subject by Piero di Cosimo that is traditionally identified as *The Death of Procris* (National Gallery, London).

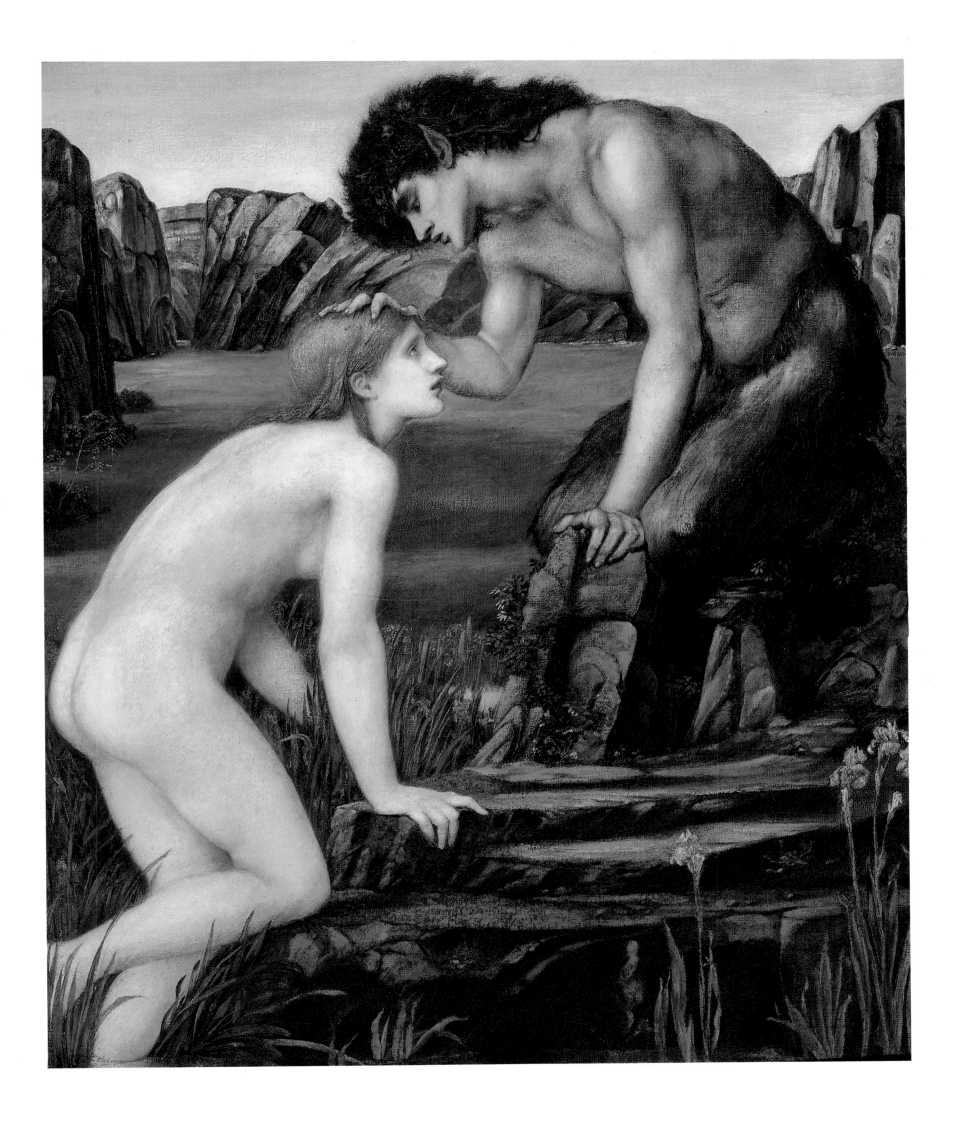

THE BEGUILING OF MERLIN
––––––––– 1874 –––––––––

Oil, 73.3 x 43.5 in / 186.2 x 110.5 cm
National Museums and Galleries on Merseyside
(Lady Lever Art Gallery, Port Sunlight)

Commissioned by the shipowner Frederick Leyland during the late 1860s, Burne-Jones commenced work on the painting in 1872. This proved a false start, however, due to a fault with new painting materials with which he was experimenting, and he began afresh in 1873. Although the picture is dated 1874, he was still making alterations to the head of Merlin during 1875 and 1876. Merlin was modelled by the American journalist William J. Stillman, a friend of Rossetti and husband of Marie Spartali, one of Rossetti's models and herself an accomplished artist. Burne-Jones had been aware of the legends of King Arthur, particularly since Morris acquired a copy of the *Morte d'Arthur* a decade earlier, and had tackled Merlin's fate in the Oxford Union murals and in *Merlin and Nimuë* (Victoria & Albert Museum, London). He now turned to an alternative version of the subject, probably deriving the hawthorn bush motif from a French medieval *Romance of Merlin*. In this Nimuë (also known by various other names, including Vivien), trades her love for lessons in enchantment from Merlin, but finally turns on him, using one of his own spells to ensnare him in a hawthorn bush and transport him to a tower as an eternal prisoner. Burne-Jones clearly had the subject in mind as early as 1858, for in that year he persuaded Tennyson not to use the name Nimuë in one of his *Idylls* (Tennyson helpfully changed it to Vivien). Nimuë, with her sinuous body and snake-entwined hair, shown consulting her book of spells, was one of Burne-Jones's first images of a *femme fatale*, a woman depicted as a seductress with a man as her helpless victim. The image was to recur repeatedly in his work, and was clearly how he viewed his own recently terminated relationship with Maria Zambaco. He later wrote to Helen Mary Gaskell, one of his several female confidantes:

'The head of Nimuë in the picture called *The Enchanting of Merlin* was painted from the same poor traitor, and was very like — all the action is like — the name of her was Mary. Now isn't that very funny as she was born at the foot of Olympus and looked and was primaeval and that's the head and the way of standing and turning... and I was being turned into a hawthorn bush in the forest of Broceliande — every year when the hawthorn buds it is the soul of Merlin trying to live again in the world and speak — for he left so much unsaid.'

Burne-Jones poured so much emotional energy into the work that after completing it he collapsed and was bed-ridden for many weeks. It was shown at the Grosvenor Gallery in 1877, where it was dramatically displayed on a red silk wall. It was variously ridiculed and praised, Henry James considering it 'a brilliant piece of simple rendering demanding a vast amount of looking on the painter's part', while William Michael Rossetti (Dante Gabriel's brother) writing in the *Athenaeum*, referred to 'the grand figure of Nimuë dark and lovely with a loveliness that looks ominous and subtle without being exactly sinister and the exquisite painting of the lavish white hawthorn bush.' One of Oscar Wilde's favourite paintings, he called it 'brilliantly suggestive' and had a photographic reproduction of it in his rooms at Oxford University. The work was shown at the 1878 Paris Exposition Universelle, making it the first of Burne-Jones's works to be shown abroad, but it failed to create the sensation that was anticipated. At the Leyland sale on 29 May 1892 it fetched £3,780 (when Whistler's *Princesse du Pays de Porcelaine* made just 420 guineas) and later entered the collection of Lord Lever. A watercolour study for the head of Maria — which Burne-Jones claimed to prefer to the finished version — came up in the studio sale of Burne-Jones's work after his death in 1898 and is now in the Bancroft Collection, Delaware Art Museum. This and further sketches in the Fitzwilliam Museum, Cambridge, and the Tate Gallery, London, indicate something of Burne-Jones's debt to classical sculpture in devising the figure of Nimuë.

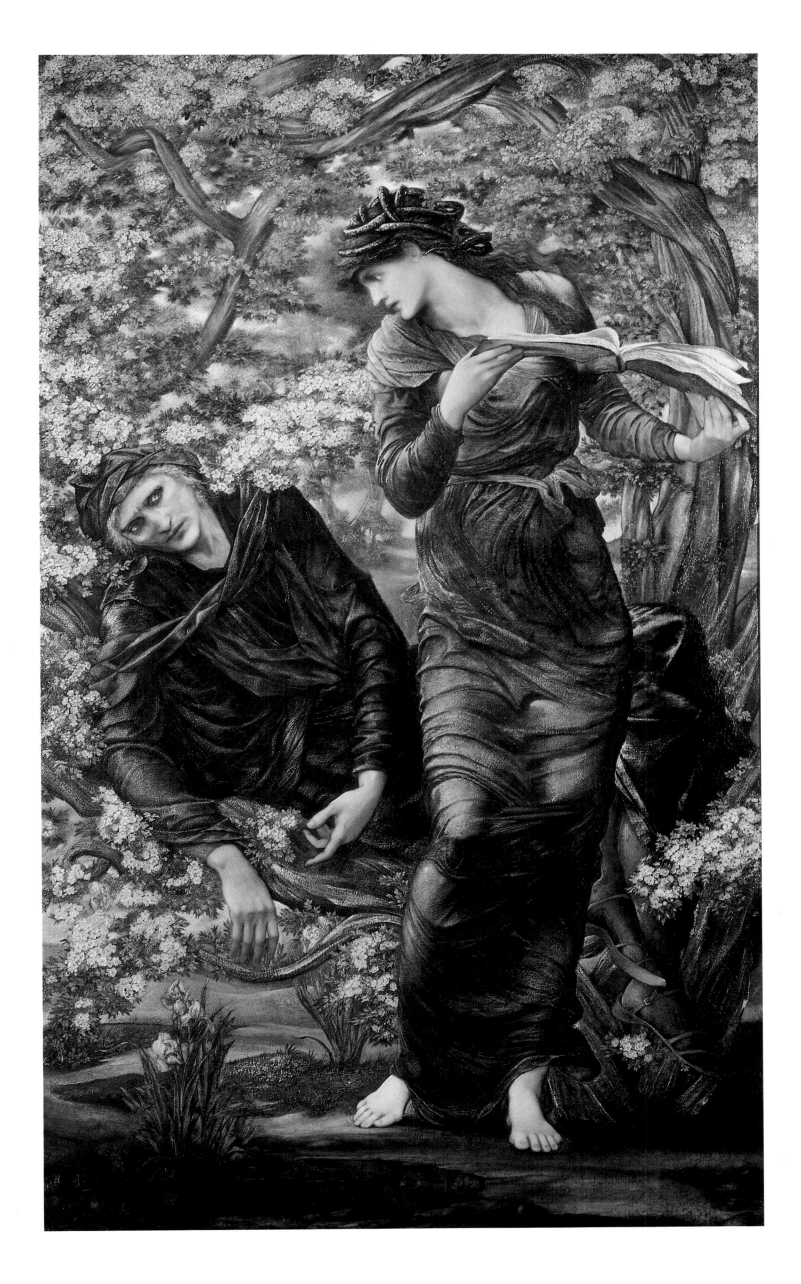

THE LAST JUDGEMENT
———————— 1874 – 75 ————————
Stained glass
St Michael and All Angels Church, Easthampstead, Berkshire

The Last Judgement, the east window of St Michael and All Angels Church, Easthampstead, was one of Burne-Jones's most ambitious stained-glass commissions to date, a large and complex subject executed by Morris and Company. Describing the window as 'one of the painter's finest efforts in this direction,' his biographer Malcolm Bell analyzed the work:

'In the centre light of this magnificent piece of decoration the stately figure of St Michael stands on a cloud, the banner of Christ in one hand, the folds of it forming a background for his head, the great scales for the weighing of good and evil in the other. Beneath him, giving solidity to the group, three winged angels are seated, the middle one of whom, with a stern expression, reads from the wide open book of doom. The angel on his right, symbolic of the sheep that shall be set on the right hand of the throne as signs of their salvation, looks on with fearless clam, while he on the left, the side of the goats that are condemned, shrinks back in horror from the dreadful sights to come. The curved line of the lower part of this mass is carried up in a graceful sweep through the lights to the right and left by cloudlets supporting angels, two on either side, blowing the great trumpets that summon the souls to judgement.'

The cartoon for the design was later coloured and exhibited at the Grosvenor Gallery in 1881. The same theme was developed in other locations, especially in the west window of St Philip's Cathedral in Burne-Jones's native Birmingham, which he produced 20 years later.

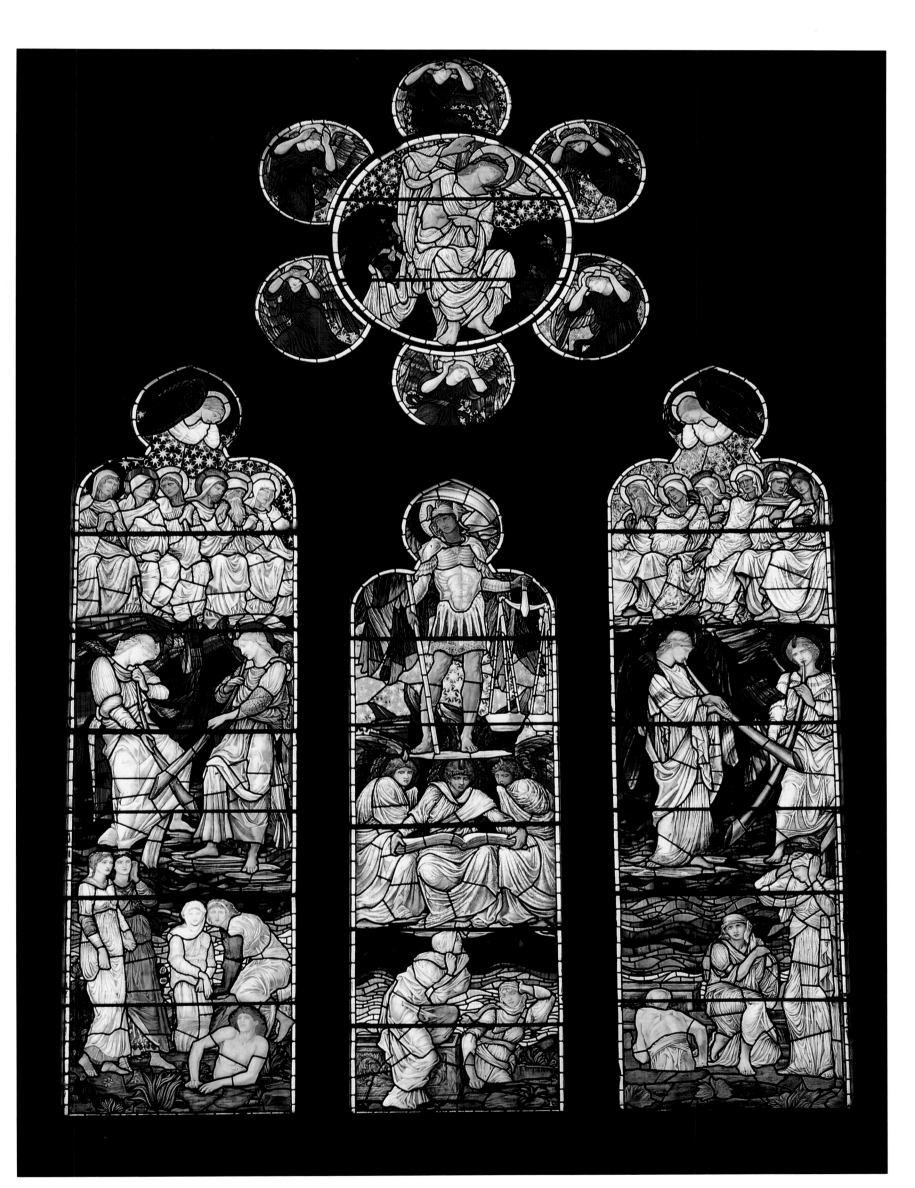

PLATE 12

THE DAYS OF CREATION—
THE FIFTH *AND* SIXTH DAYS
——————— 1870 – 76 ———————

Watercolour, gouache and shell gold on linen, 40.1 x 14 in / 101.9 x 35.6 cm
Watercolour, gouache and shell gold and platinum paint on linen,
40.1 x 14 in / 101.9 x 35.6 cm
The Fogg Art Museum, Harvard University, Cambridge, Massachusetts
Bequest of Grenville L. Winthrop

The series of six 'Days of Creation' watercolours originated as designs for a stained-glass commission for a church in Tamworth, Staffordshire. Each successive 'day' consists of a number of angels corresponding to that day – thus the fifth day has five angels. In each, the angel in the foreground holds a sphere in which the events of the day are presented as related in the bible, so that the progressive creation of the universe is seen as a sequence in which the previous angels withdraw into the background: 'The fifth,' as described by Malcolm Bell, 'stands upon the wet sea-margin strewn with fragile shells, and supports a globe containing a swift whirl of white-winged sea-birds sweeping up from the stormy waters,' while behind and to the left is the fourth day, on which the sun and moon were created.

The last in the six *Days of Creation* series actually represents both the sixth and seventh days, as explained by Malcolm Bell: 'The sixth and last shows Adam and Eve new met in the Garden of Eden beside the forbidden tree, behind which the great coils of the threatening serpent are faintly shadowed forth. At the feet of the Angel of this sixth day sits the seventh, the Angel of the day of rest, flower-garlanded among roses, playing upon a many-stringed instrument.'

Variously called *The Days of Creation* and *The Angels of Creation*, their completion totally occupied Burne-Jones during the first five months of 1876, with Jenny Morris, William's daughter, posing for some of the angels. The entire set of six was originally owned by William Graham and was sold after his death in 1885 for £1,732, eventually finding its way to the Fogg Art Museum.

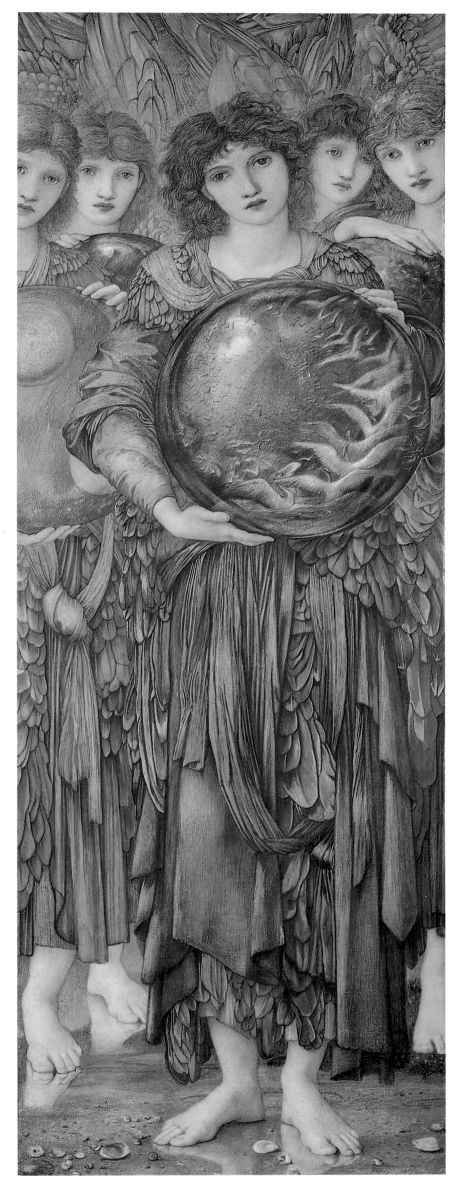
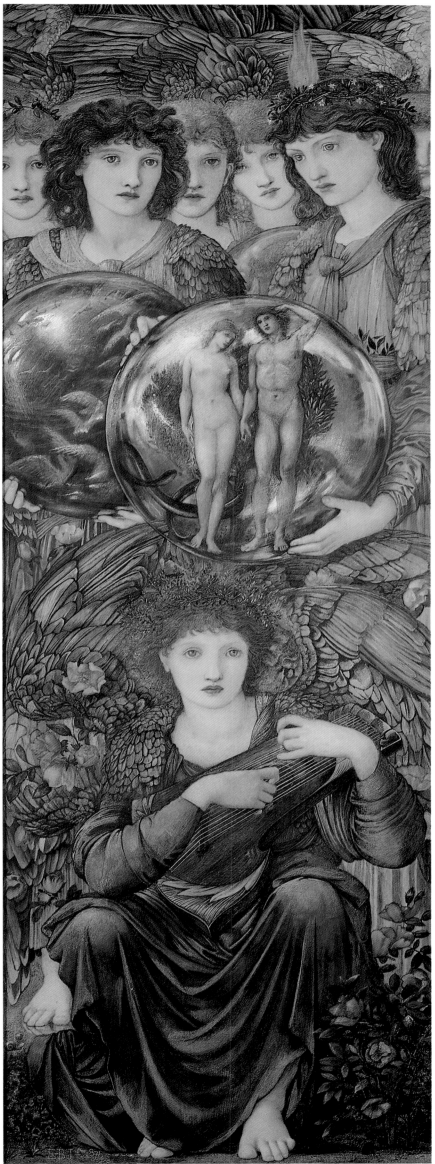

Le Chant d'Amour
—————— 1868–77 ——————
Oil, 44.9 x 61.4 in / 114 x 156 cm
The Metropolitan Museum of Art, New York,
The Alfred N. Punnett Endowment Fund, 1947

The theme of music and musical instruments recurs constantly in Burne-Jones's work. Georgiana Burne-Jones was an accomplished musician and she and her husband numbered many notable musicians among their friends. Here an ancient Breton song that was probably known to Georgiana provides the subject and title for the painting: *Hélas! je sais un chant d'amour/Triste ou gai, tour à tour* (Alas, I know a love song/Sad or merry, each in turn). The work depicts an organist with a figure representing Love operating the bellows. The figure of Love is sightless ('Love is blind'), while Burne-Jones's abiding interest in the language of flowers is manifest in the painting, where tulips (symbolizing 'ardent love') and wallflowers ('bitterness') jointly represent the contradictory emotions expressed in the song.

The subject was originally painted in about 1864 on the inside of the lid of the upright piano (now in the Victoria & Albert Museum) that Edward and Georgiana had received as a wedding gift four years earlier, and it was from this, over a number of years, that he developed the full-sized painting. Also, ironically, in view of its origin within the Burne-Jones family, the same subject appears as an illustration within the illuminated medieval manuscript in his *Portrait of Maria Zambaco* of 1870 (Plate 7). In the intervening years, Burne-Jones developed the theme, adding the figure of the knight in a watercolour version (1865; Museum of Fine Arts, Boston – one of the first Burne-Jones pictures to arrive in the United States) that was acquired by his patron William Graham, who then commissioned this large replica. The oil version of *Le Chant d'Amour* was shown publicly in 1878 at the second Grosvenor Gallery exhibition. Henry James, a visitor to the Gallery, remarked that 'we should hardly know where to look for a more delicate rendering of a lovesick swain', considering the colour 'like some mellow Giorgione or some richly-glowing Titian.' At the sale following Graham's death in 1885, it fetched the highest price of £3,307, sustaining its price when it was re-sold in the year of Burne-Jones's death.

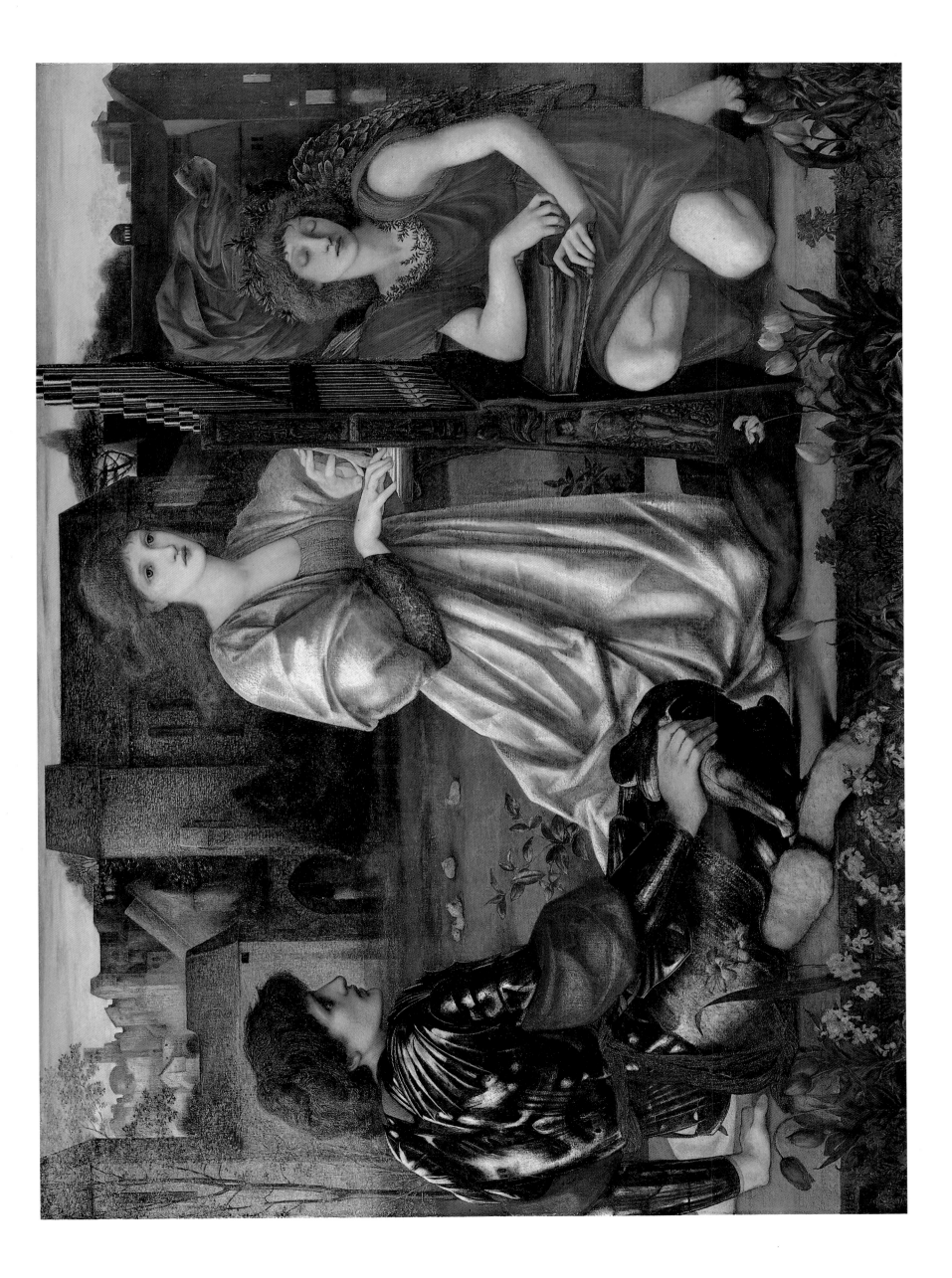

THE MIRROR OF VENUS
———————— 1870 – 76 ————————
Oil, 47.2 x 78.7 in / 120 x 200 cm
Calouste Gulbenkian Foundation, Lisbon

Produced as an avowedly aesthetic image with no specific reference to any legend, this is the large version of a painting dating from 1866–77, in which Venus and her handmaidens gaze at their own reflections in a pool in a rocky landscape that could have come from Botticelli or Leonardo da Vinci. Commissioned by Leyland, Burne-Jones devoted three months to the work in 1874 alone. In her *Memorials of Edward Burne-Jones* Georgiana notes that when Ruskin saw the oil in progress he was convinced that it was a watercolour. It was eventually shown at the first Grosvenor Gallery exhibition in 1877, sold after Leyland's death for 3,570 guineas, and again in May 1898 for 5,450 guineas, finally entering the collection of the Calouste Gulbenkian Foundation, Lisbon. There are studies of the work in the Fitzwilliam Museum, Cambridge, and the Tate Gallery, London.

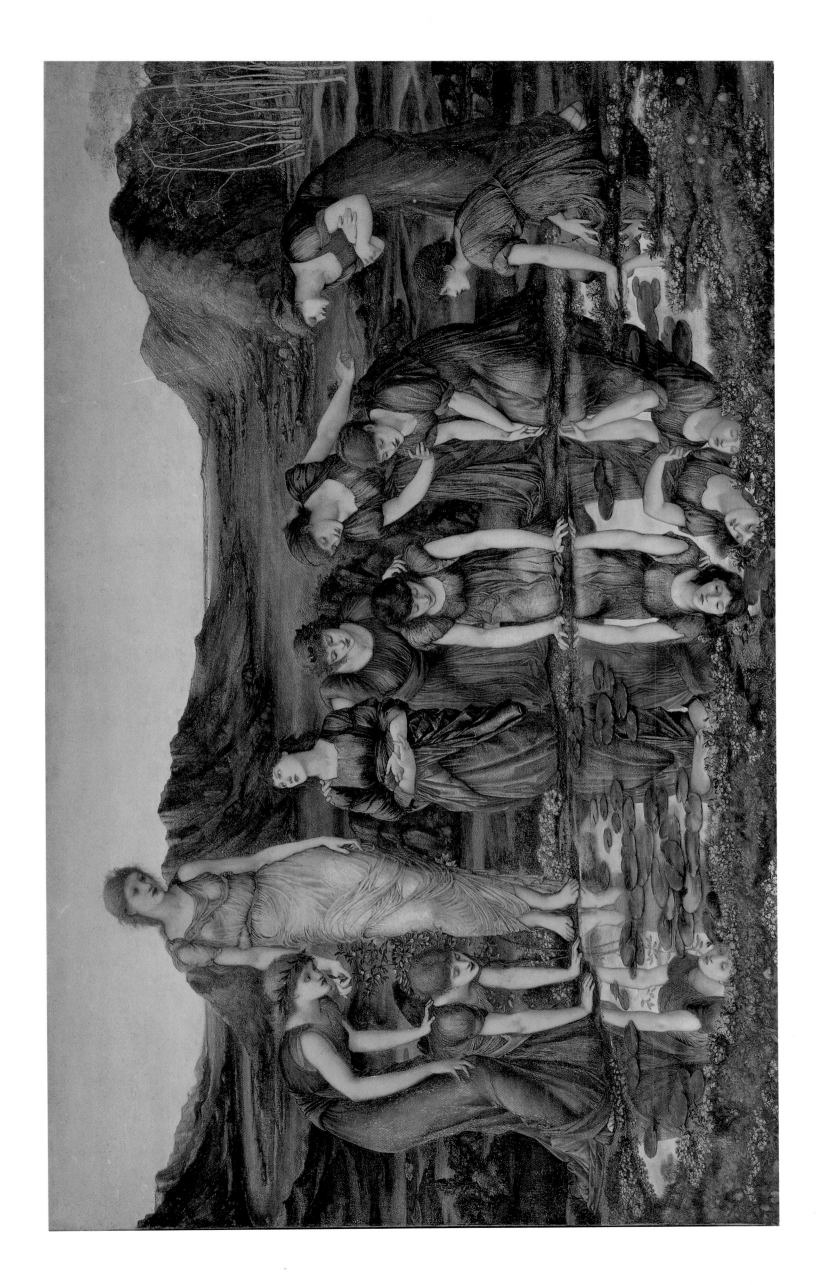

PYGMALION AND THE IMAGE—
THE GODHEAD FIRES

————————— 1868–78 —————————

Oil, 38.4 x 29.5 in / 97.5 x 74.9 cm
Birmingham Museums and Art Gallery

As told in Ovid's *Metamorphoses*, the legend relates how Pygmalion, a misanthropic king of Cyprus, having built an ivory statue, fell in love with it. Answering his prayers, the goddess Venus gave life to the statue, who, naming her Galatea, he married. In 1867 Burne-Jones executed 12 illustrations based on the story for William Morris's *The Earthly Paradise*, subsequently developing a sequence of four paintings on the identical theme: *The Heart Desires*, *The Hand Refrains*, *The Godhead Fires* and *The Soul Attains*. His first series of four oils was painted in 1868–70 for Euphrosyne Cassavetti, the mother of Maria Zambaco, while the more detailed set from which this subject and the next come, spanning a longer period of execution, was shown at the Grosvenor Gallery in 1879 and purchased by Frederick Craven.

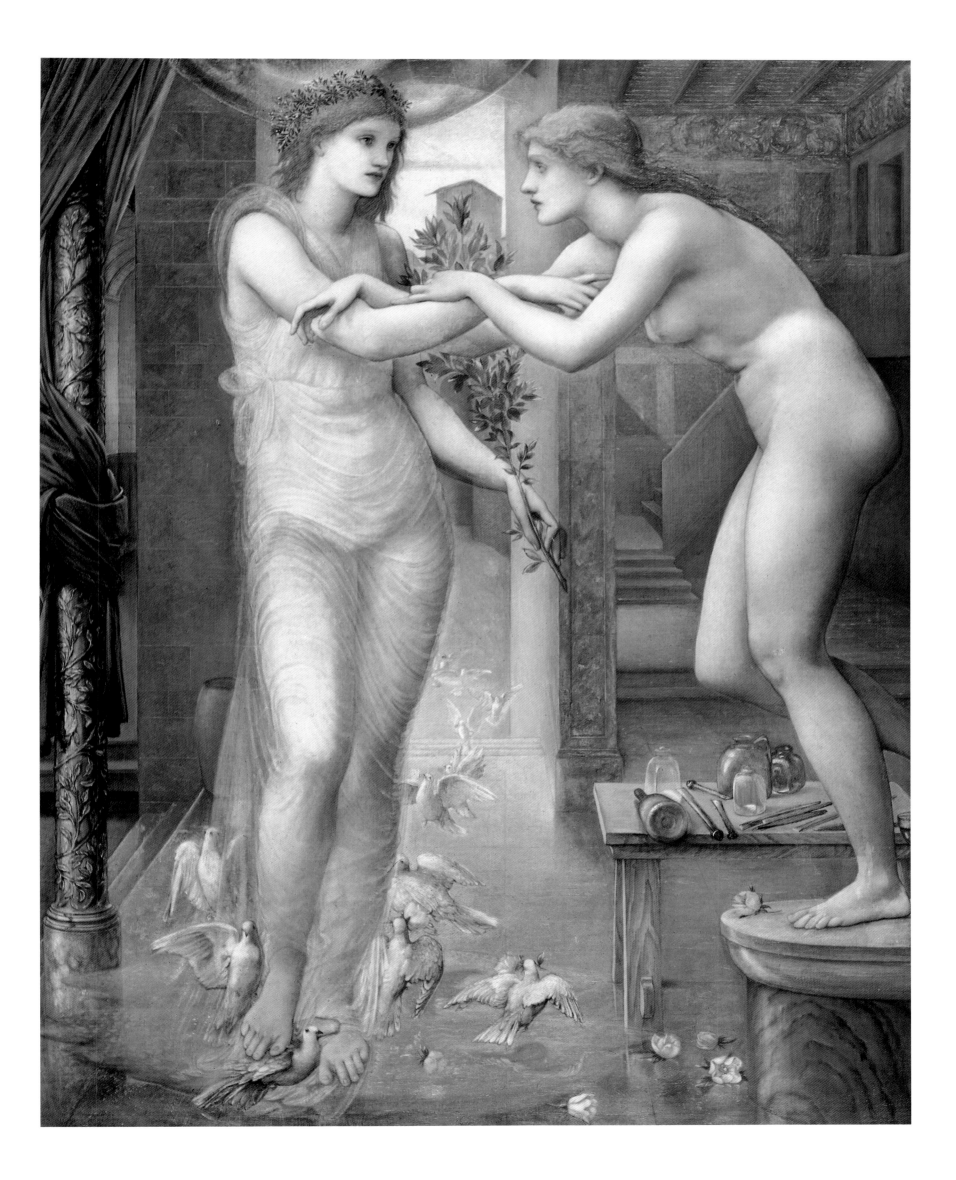

PYGMALION AND THE IMAGE — THE SOUL ATTAINS

———— 1868 – 78 ————

Oil, 38.4 x 29.5 in / 97.5 x 74.9 cm
Birmingham Museums and Art Gallery

For his *Pygmalion and the Image* series Burne-Jones modelled Pygmalion's head on W. A. S. Benson, appropriately a craftsman himself, and later the architect responsible for the conversion of the Burne-Jones's Rottingdean property. Coincidentally, in 1871, while Burne-Jones was at work on the paintings, W. S. Gilbert's comedy *Pygmalion and Galatea* was first performed on the London stage.

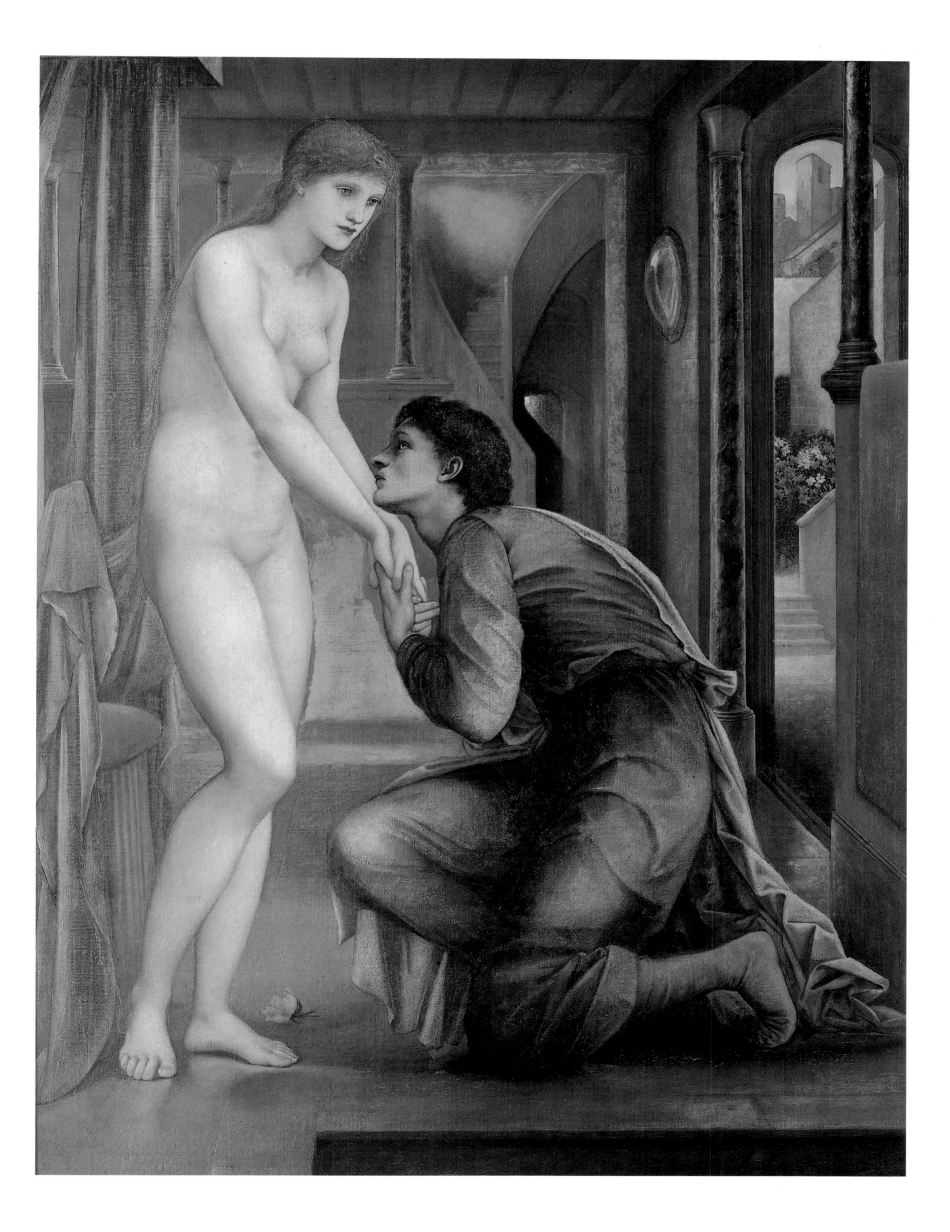

LAUS VENERIS
——— 1868 ———
Oil and gold paint, 48 x 72 in / 122 x 183 cm
Laing Art Gallery, Newcastle upon Tyne

A German legend relates how Tannhäuser, the poet and wandering knight, discovered the Venusberg, the subterranean home of Venus, goddess of love, and spent a year there with her. Released and filled with remorse for his sinful behaviour, he travelled to Rome to seek absolution from Pope Urban, who told him that forgiveness would be as impossible as that his papal staff should blossom. Tannhäuser returned to Venus, and three days' later the Pope's staff miraculously flowered. During the Romantic period, numerous German writers produced versions of the Tannhäuser story, many of which were translated into English, the best-known appearing in Thomas Carlyle's *German Romance* of 1827. Later, William Morris retold the legend as 'The Hill of Venus' in his *The Earthly Paradise* (1868–70). Two other versions had appeared in 1861 when Burne-Jones himself first tackled the subject as a watercolour that was acquired by his patron, William Graham, who was to commission the larger oil painting. This was started in 1873, finished five years later and shown at the second Grosvenor Gallery exhibition. The critical response was generally favourable, F. G. Stephens in the *Athenaeum* declaring it 'the finest work he has achieved' and a source of 'unending pleasure' – but it was also attacked as an example of all that was held by some to be despised in the Aesthetic Movement: the peacock feathers on the floor alone would have been sufficient to identify its dubious 'aesthetic tendencies'. Algernon Swinburne produced a poem with the same title, which similarly explored the theme of the destructive power of love, publishing it in *Poems and Ballads*, which he dedicated to Burne-Jones, in 1866. A mutual influence has been suggested: Swinburne probably saw the watercolour version before writing the poem, while Burne-Jones, having read the poem, incorporated many of its images into his painting. Certain phrases in it replicate poetically the mood Burne-Jones conjures up on canvas, including its almost claustrophobic atmosphere and the predominant use of red tones: 'Her little chambers drip with flower-like red', in Swinburne's verse. Further contemporary influences that have been proposed include Charles Baudelaire's *Les Fleurs du Mal* (1857) and Wagner's *Tannhäuser*, performed in Paris in March 1861 and at the Royal Opera House in 1876. Both Swinburne and Burne-Jones were admirers of Wagner, and in 1863 Baudelaire sent Swinburne his pamphlet, *Richard Wagner et Tannhäuser à Paris*.

W. Graham Robertson saw *Laus Veneris* as resembling 'clusters of many-coloured gems or stained windows through which shone the evening sun', and in a letter describing the Burne-Jones centenary exhibition of 1933 asked a friend, 'I wonder which you consider his best picture? I should vote for *Laus Veneris*…a lovely, glowing thing – as fresh and brilliant as ever after all the years.' Robertson's opinion is widely shared, and the work is regarded as the finest example of Burne-Jones's skill in composition and use of surface pattern. It resembles a tapestry with exceptionally rich textures, that of the dress of Venus being achieved by stippling with a circular punch in the underpaint before the colour was added. The vivid contrast the painting must have made against the green walls of the Grosvenor Gallery, where it was first exhibited, can only be imagined. The actual tapestry on the right of the painting depicts Venus in a chariot and was created in 1861 as a design for tiles and in 1898 adapted as a tapestry made by William Morris's company.

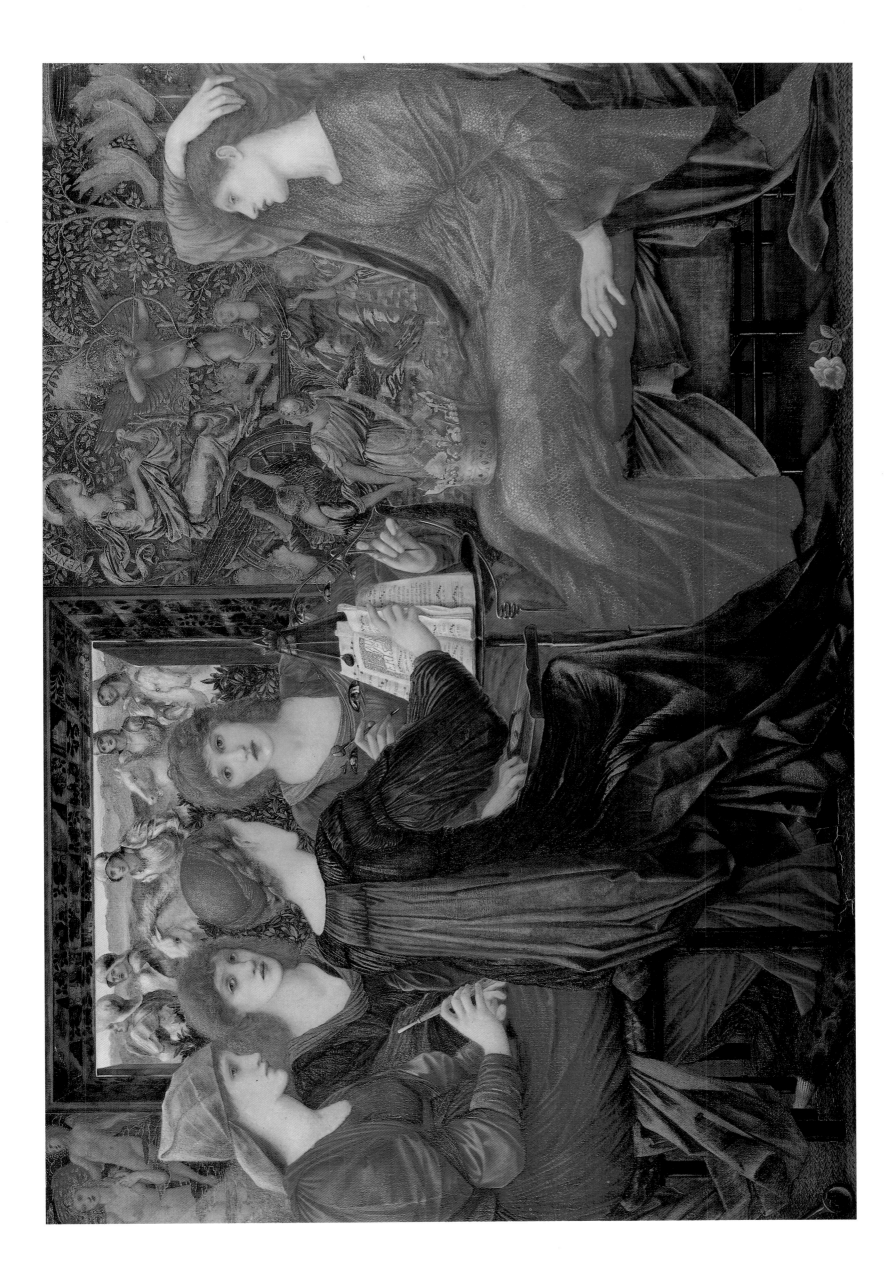

PLATE 18

THE ANNUNCIATION
—— 1879 ——

Oil, 98.5 x 41 in / 250.1 x 104.1 cm
National Museums and Galleries on Merseyside
(Lady Lever Art Gallery, Port Sunlight)

Annunciations became something of a stock-in-trade for Burne-Jones: the same subject, along with a *Nativity*, had been commissioned from him in 1862 for a bible produced by the Dalziel brothers, and on numerous subsequent occasions for stained glass. In this version, the expulsion from Eden frieze on the wall was derived directly from a stained-glass design. Sketches for the composition are in the Fitzwilliam Museum, Cambridge, and the original cartoon re-worked in watercolour in the Castle Museum, Norwich. The oil, which was originally in the George Howard collection, was modelled by Sara Prinsep's niece Julia. In 1878 she had become the wife of the writer Leslie Stephen, and was appropriately painted while pregnant with her first child, Vanessa Stephen, later Bell (herself destined to become an artist, and the elder sister of Virginia Woolf), who was born on 3 May 1879. Having decided against a career in the church, the myth and mystery of his art became a substitute for religion in Burne-Jones's life. He created a highly personal adaptation of the Christian view of life, in Lord David Cecil's words, making it 'a search for spiritual salvation to be achieved with the help of the specifically Christian virtues of charity, humility and mercy', yet despite the gravity of his religious subjects, and especially his church stained-glass work, Burne-Jones's mythological works are invariably more deeply felt and convincing.

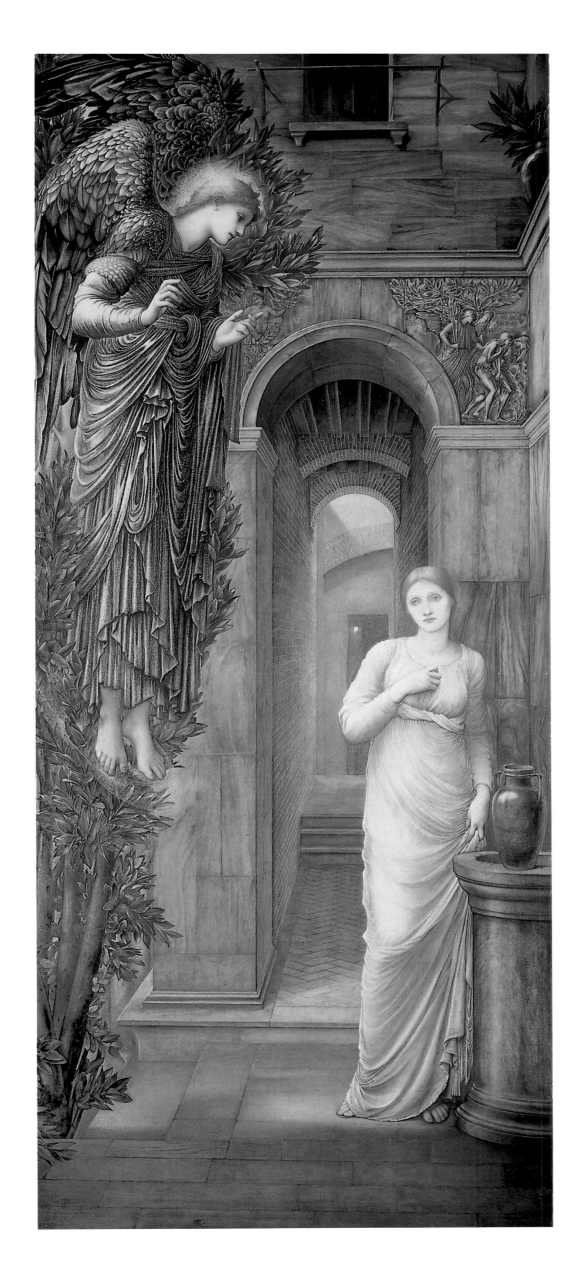

THE GOLDEN STAIRS
——————— 1872–80 ———————
Oil, 109 x 46 in / 277 x 117 cm
Tate Gallery, London

Burne-Jones often worked for several years on his paintings, many of which were created to the large scale of this work, which stands some nine feet tall. The picture was designed in 1872, but not begun until 1876, and was completed just in time to be shown at the Grosvenor Gallery in 1880. Georgiana Burne-Jones noted in her diary on 22 April 1880, 'The picture is finished, and so is the painter almost. He has never been so pushed for time in his life.' Burne-Jones himself wrote that 'I have drawn so many toes lately that when I shut my eyes I see a perfect shower of them.' F.G. Stephens, reviewing the Grosvenor exhibition in the *Athenaeum* on 8 May, remarked that the figures 'troop past like spirits in an enchanted dream, each moving gracefully, freely, and in unison with her neighbours... What is the place they have left, why they pass before us thus, whither they go, who they are, there is nothing to tell.' Victorian critics and the public alike invariably sought the 'meaning' or story behind every painting, but were frequently thwarted by Burne-Jones. Letters to the publication *Notes and Queries* asking for an explanation of this work evinced contradictory replies, and like several of his paintings, its subject is without specific literary or historical reference (he considered several alternatives including *The King's Wedding* and *Music on the Stairs*), although the title is derived from a passage by Dante. In many Aesthetic and Symbolist works, such as Whistler's 'Symphonies' and 'Nocturnes', connections are often drawn between art and music. Burne-Jones and his family were noted for their love of music, and here, as in many of his most successful paintings, the figures carry or are playing musical instruments, but neither the final title nor the painting itself offers us any clues as to the circumstances of this musical procession, and we must conclude that it possesses no 'subject' beyond being an exercise in Aesthetic composition.

This painting belongs to a group of works of this period which are pale, almost monochromatic and highly classical, contrasting with the richly coloured *Laus Veneris*. F. G. Stephens had evidently seen the work in progress and commented: 'Since we first saw this picture it has lost much of that Greek quality we then admired... It has been modified, and now resembles in many points the art of Piero della Francesca. The pale golden carnations, the broad foreheads, the deep-set, narrow eyes and their fixed look, even the general contours and the poising of the heads on the shoulders, plainly tell of the influence of that lovely painter and poetic designer.' Many studies for the work are known – those for the hands and feet, for example, are in the Fitzwilliam Museum, Cambridge. A well-known Italian professional model, Antonia Caiva, modelled nude for all the bodies, which accounts for the chorus-line equality of their proportions, while the heads of the eighteen women were mostly members of Burne-Jones's family and his friends: they perhaps include his daughter Margaret at the bottom of the stairs with arm and waist wreaths, Edith Gellibrand, an actress, bending on the staircase, Laura Lyttleton and May Morris, facing, right centre, Frances Graham, the daughter of his patron William Graham, holding cymbals in the bottom left, and Mary Stewart Wortley, the second of the two entering the doorway. *The Golden Stairs* entered the collection of Cyril Flower, later Lord Battersea, and his wife Constance, a member of the Rothschild family, but it became widely known through popular engravings. It was said to have become an important inspiration for W.S. Gilbert in writing his operetta *Patience*, first produced in 1881, which satirized the Aesthetic Movement.

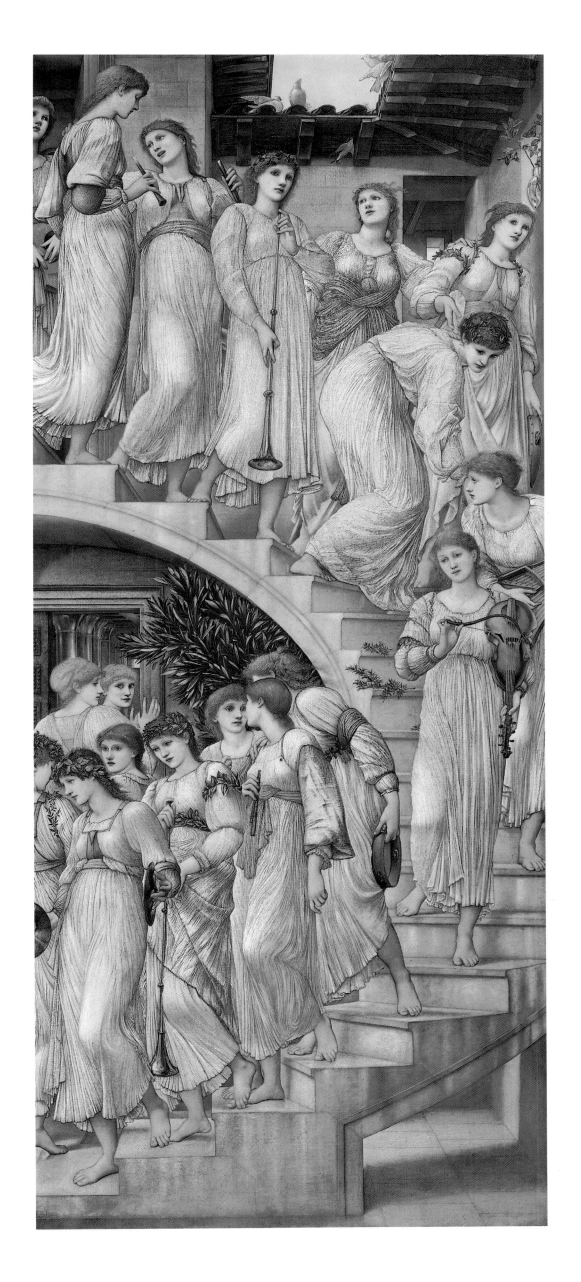

THE MILL
—— 1872 – 80 ——
Oil, 35.8 x 77.8 in / 90.9 x 197.6 cm
Victoria & Albert Museum, London

Constantine Ionides, the wealthy Greek businessman patron of
Burne-Jones, commissioned this work which Burne-Jones begun in
1870. It was shown at the Grosvenor Gallery in 1882 and ultimately
entered the Victoria & Albert Museum through the Ionides Bequest.
Modelled by Maria Zambaco, Aglaia Coronio (Constantine Ionides'
sister) and Marie Spartali (whose husband was Merlin in *The
Beguiling of Merlin*), The Three Graces — as the three models, who
were also cousins, were known in the artistic community — dance to
the music of Love. The naked men in the pool behind perturbed
Henry James in his review, and when the Royal School of Art
Needlework created an embroidered version, this detail was deliber-
ately omitted. The mill from which the title is derived is almost a
minor element, with minute punting millers and grain sacks in the
background, but there is the implied symbolism of the water mill as
a natural (in modern jargon, 'green') source of energy, and the
harmony between work and play. The work has affinities to Botti-
celli 's *Primavera*, which similarly depicts Three Graces dancing, and
other Italian masters, and was also influenced by Rossetti's illustra-
tions for *The Maids of Elfen-Mere*, which Burne-Jones is known to
have admired. Marie Spartali also appears in Rossetti's *The Bower
Meadow* of 1872 (Manchester City Art Gallery), which, like *The Mill*,
depicts girls dancing in a field.

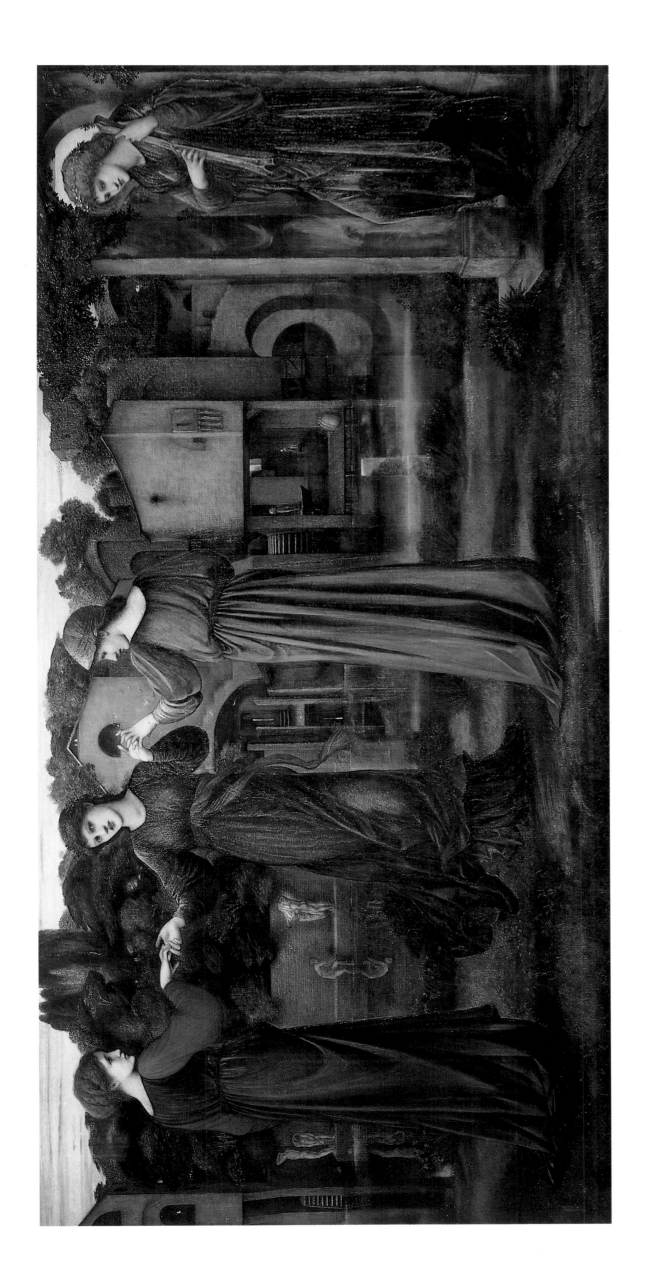

THE HOURS
——— 1870 – 82 ———
Oil, 34 x 72.7 in / 86.5 x 183.5 cm
Sheffield City Art Galleries

This row of draped figures has close affinities to the Aesthetic works of Albert Moore, the pre-eminent exponent of the genre, who in the same year, 1882, produced a similar subject depicting a seated group of women in various states of repose (*Dreamers*, Birmingham City Art Gallery). Although dated 1882, Burne-Jones was clearly still putting the finishing touches to the painting the following year, since he then wrote a letter to Lady Leighton, telling her, 'I have been working hard in spite of all things, and hope to finish the *Wheel of Fortune* and the *Hours*. I think you never saw the last – not a big picture, about five feet long – a row of six little women that typify the hours of day from waking to sleep. Their little knees look so funny in a row that wit descended on from above, and I called them the "laps of time". Every little lady besides the colour of her own frock wears a lining of the colour of the hour before her and a sleeve of the hour coming after – so that Mr Whistler could, if he liked, call it a fugue.'

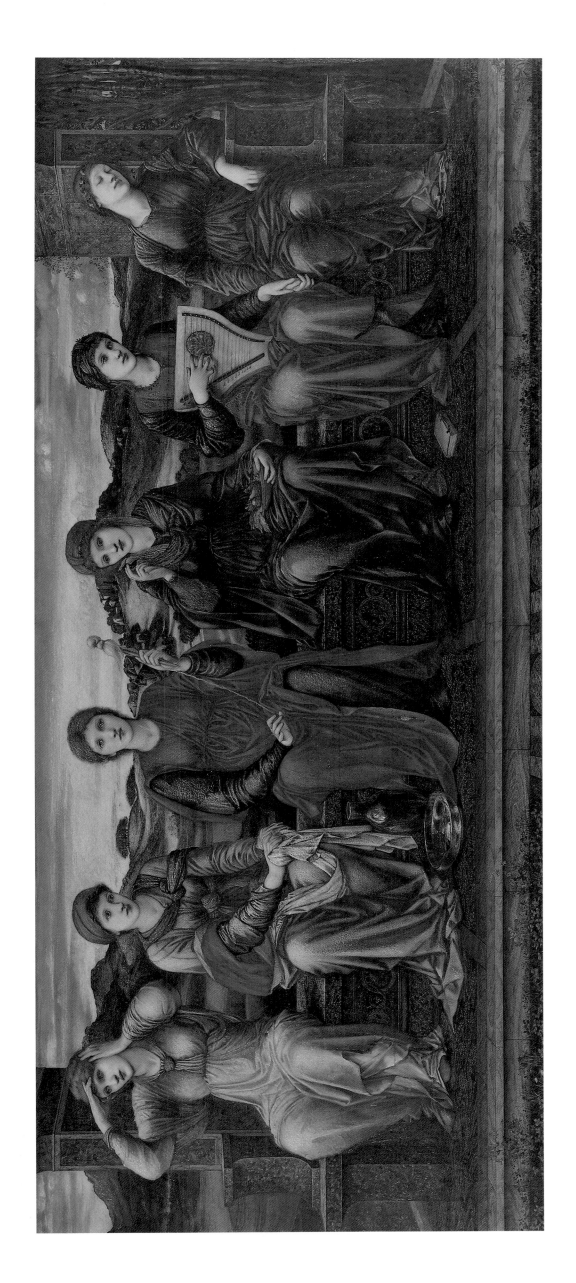

PLATE 22

TREE OF FORGIVENESS
———————— 1881–82 ————————
Oil, 75 x 42 in / 190.5 x 106.7 cm
National Museums and Galleries on Merseyside
(Lady Lever Art Gallery, Port Sunlight)

Various versions of the Greek legend, related in both Ovid's *Heroides* and Chaucer's *Legend of Good Women*, tell how Phyllis, queen of Thrace, falls in love with Demophoön, king of Melos, the son of Theseus and Phaedra, who visits her court en route for Athens after the Trojan War (where he had hidden inside the Trojan Horse). He left the court, but when he failed to keep his promise to return within a month, she committed suicide, whereupon Athena, taking pity on her, turned her into an almond tree. Eventually, Demophoön returned to Thrace and, discovering what had happened, embraced the tree, which immediately burst into blossom.

Burne-Jones's first version of the subject, *Phyllis and Demophoön*, was the cause of his rift with the Old Water-Colour Society in 1870. In Great Britain, the 1870s was a sensitive decade on the issue of nudity in art, even if it was made respectable by classical references (Alma-Tadema, later a master of the genre, did not risk presenting a nude to public scrutiny until 1875 and was attacked for his 1877 work, *A Sculptor's Model*). Burne-Jones's work went too far, presenting both a male and female nude clasped together. The *Times* critic observed that the 'idea of a love-chase, with a woman follower, is not pleasant.' There was a further underlying cause for complaint among those in the know, for the figure of Phyllis was modelled on Burne-Jones' mistress, Maria Zambaco, while Demophoön, representing Burne-Jones himself, struggles to free himself from his forgiving former lover. As if to add emphasis to his turbulent affair, he took from Ovid the phrase, 'Tell me what I have done, except to love unwisely', and appended it to the picture.

Tree of Forgiveness, which was originally owned by William Morris, is a later oil version of the *Phyllis and Demophoön* gouache, shown at the Grosvenor Gallery in 1882, which reverses the subjects' nudity: the formerly partly draped Phyllis is now totally naked, while the previously totally nude Demophoön, clutched in her erotic embrace, is barely disguised by an improbably convenient wisp of fabric. The sturdier male figure in the second version indicates Burne-Jones's debt to Michelangelo.

PLATE 23

THE WHEEL OF FORTUNE
———————— 1875–83 ————————
Oil, 78.35 x 39.4 in / 199 x 100 cm
Musée d'Orsay, Paris

The Wheel of Fortune is part of an ambitious (and never completed) series of paintings for a triptych on the Fall of Troy, a theme planned as an epic poem by William Morris (and also never finished) in which four sections were designed to represent Fortune, Fame, Oblivion and Love. The work is known from an unfinished oil representing the whole grand conception (Birmingham City Art Gallery), and paintings derived from sections of it, such as versions of the *Feast of Peleus* (Birmingham; Victoria & Albert Museum) and *Venus Discordia* (National Museum of Wales, Cardiff). In this work, the allegorical figure of Fortune turns her wheel to which are bound, at the top, a slave, in the centre, a king, and at the bottom a poet. The composition is derived from the Mantegna altarpiece in San Zeno, Verona, which Burne-Jones saw in 1862, while the unusually robust male figures show the influence of Michelangelo, as does the figure of Fortune which resembles a Sibyl in the Sistine Chapel (Burne-Jones had studied them in detail in 1871, reportedly by lying on his back with a pair of opera glasses). Several versions of this subject are in the collections of the National Museum of Wales, Hammersmith Public Libraries, the National Gallery of Victoria, Melbourne, and the Watts Gallery, Compton, but this was his personal favourite among his entire oeuvre. In 1893 Burne-Jones wrote to Helen Mary Gaskell, telling her, 'my Fortune's Wheel is a true image, and we take our turn at it, and are broken upon it.' Fortune's head-dress was created by Alice Comyns Carr, the wife of the Grosvenor Gallery director Joseph Comyns Carr, who designed stage costumes for the actress Ellen Terry. The scale of the figures is somewhat bizarre, but the disproportion was perhaps a deliberate reflection of the technique found in ancient art whereby important characters are represented in sizes in proportion to their status. Burne-Jones is recorded as having worked round the clock to complete this picture for the Grosvenor Gallery exhibition of 1883, where it was warmly praised and acquired by Arthur Balfour, for whom Burne-Jones was already commissioned to produce the *Perseus* series. Acquired by a French collector after Balfour's death, (the Luxembourg had already acquired related drawings), it entered the French national collection as recently as 1980.

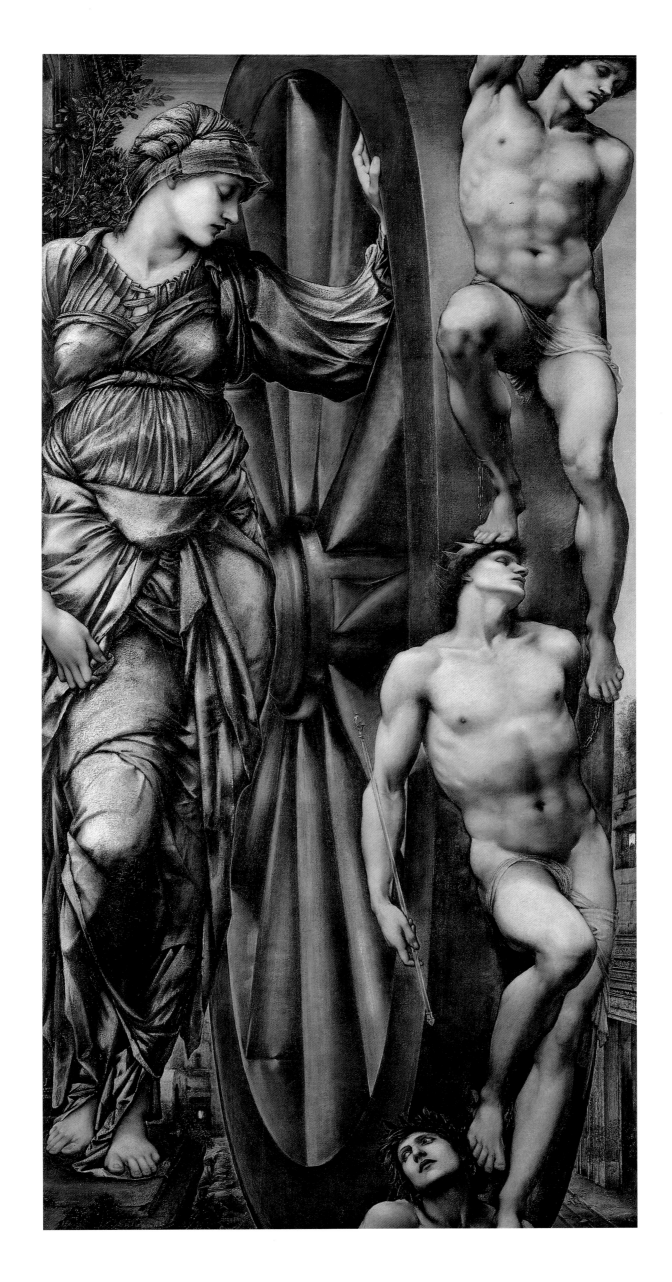

PLATE 24

KING COPHETUA AND THE BEGGAR MAID

———— 1884 ————

Oil, 114.2 x 53.5 in / 290 x 136 cm
Tate Gallery, London

The subject of the work is an Elizabethan ballad, retold in Tennyson's poem *The Beggar Maid*, in which a king searches for a pure wife. After finding her, the king offers his crown in return for the love of the ragged beggar girl, who in Burne-Jones's painting sits as if enthroned while he sits beneath her in homage. The anemones in the girl's hand symbolize rejected love, while the characters represents Burne-Jones himself and his wife Georgiana; it is said that the head of the king had to be modified to make its model's identity less obvious. Starting with a small oil version in about 1861, Burne-Jones progressively developed the theme with an extensive series of pencil studies of the various elements (now in the Birmingham City Art Gallery, Manchester City Art Gallery, the Ashmolean Museum, Oxford, and the Fitzwilliam Museum, Cambridge). Certain details were derived from actual objects – the crown, for example, was specially made by W. A. S. Benson. Burne-Jones commented in a letter, 'I work daily at *Cophetua and his Maid*. I torment myself every day – I never learn a bit how to paint. No former work ever helps me – every new picture is a new puzzle and I lose myself and am bewildered – and it's all as it was at the beginning years ago. But I will kill myself or Cophetua shall look like a King and the beggar like a Queen, such as Kings and Queens ought to be.' He had worked on it for so long that he had grown '…very tired of it – I can see nothing any more in it, I have stared out of all countenance and it has no word for me. It is like a child that one watches without ceasing until it grows up, and lo! it is a stranger.'

The resultant somewhat laboured and overworked quality of the painting has attracted a degree of criticism, yet it remains one of Burne-Jones's most impressive and best-known images. When the huge painting was exhibited at the Grosvenor Gallery in 1884, the art critic of *The Times*, which had previously been only moderate in its praise of Burne-Jones, described it as 'not only the finest work that Mr Burne-Jones has ever painted, but one of the finest pictures ever painted by an Englishman.' It also received acclaim when it was shown in Paris at the Exposition Universelle in 1889 (at which the centre of attraction was the newly-completed Eiffel Tower). Burne-Jones was duly awarded the Croix de Legion d'Honneur. The painting was shown in England at the New Gallery in 1892 and again at the memorial exhibition after Burne-Jones's death. Following this last showing, Georgiana hoped that it would go to the National Gallery, but it was acquired by the Tate Gallery.

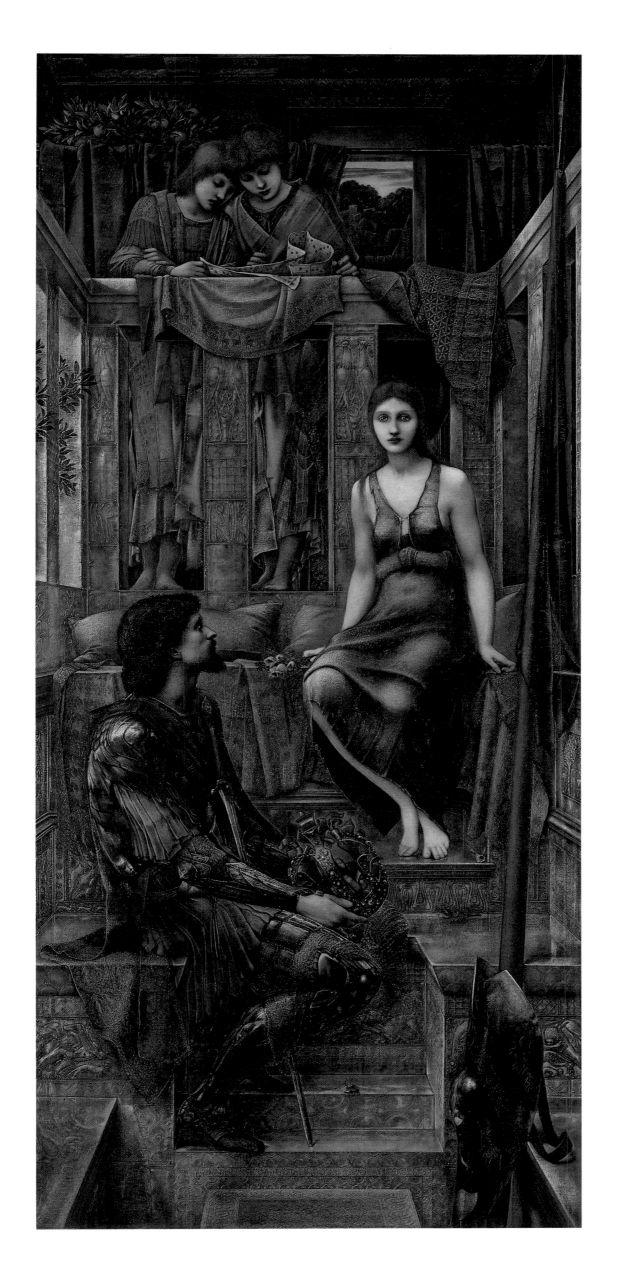

PLATE 25

SIBYLLA DELPHICA
—— 1868 ——
Oil, 60.2 x 23.7 in / 152.8 x 60.3 cm
Manchester City Art Galleries

Described by Malcolm Bell as 'a figure in a gorgeous orange robe standing in a doorway beside a burning tripod and reading the mystic messages,' Sibylla Delphica, or the Delphic Sibyl, was the priestess of Apollo who presided over the Oracle at Delphi, where she wrote her prophecies on bay leaves. Burne-Jones painted classical subjects and draped figures in wet, clinging robes, this vivid one resembling the pale girls previously seen processing in *The Golden Stairs*.

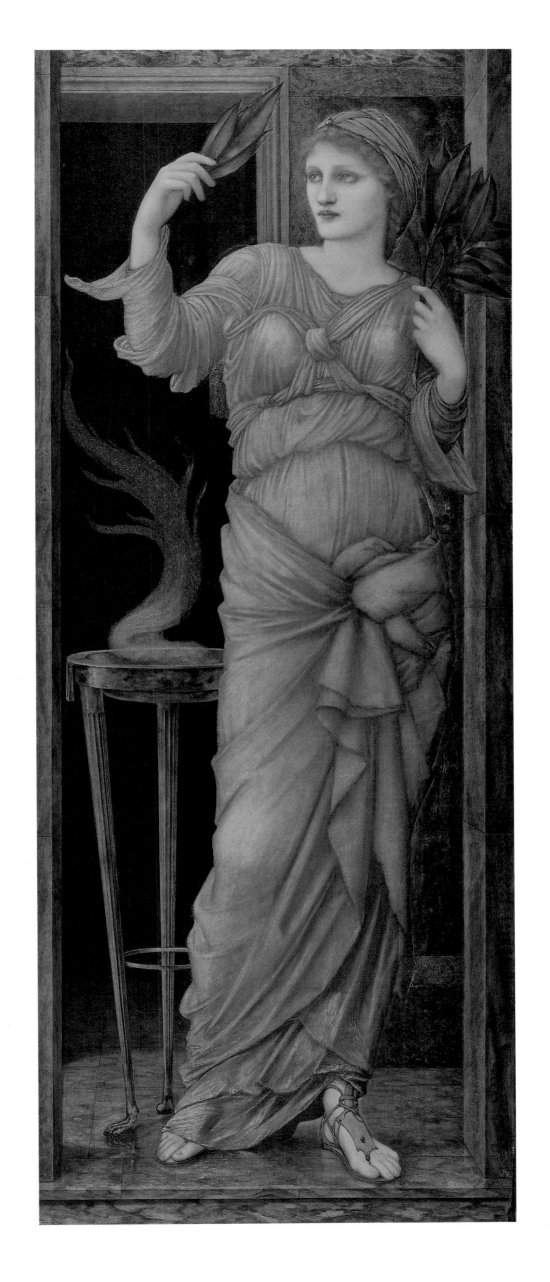

PLATE 26

THE DEPTHS OF THE SEA
——————— 1887 ———————
Watercolour and gouache, 66.7 x 29.8 in / 169.4 x 75.8 cm
The Fogg Art Museum, Harvard University, Cambridge, Massachusetts
Bequest of Grenville L. Winthrop

Burne-Jones was elected an Associate of the Royal Academy in 1885, but resigned eight years later, having only ever exhibited a single work, an oil of *The Depths of the Sea* (private collection). This is a watercolour version of the same subject, painted after experiments with the effects of underwater light in a water tank loaned to him by the painter Henry Holiday. The shoal of fishes was added after encouragement by Lord Leighton, who saw the work in progress to check its suitability for exhibition at the Academy. Like *The Beguiling of Merlin* and *Phyllis and Demophoön/Tree of Forgiveness*, the image is one of man and woman engaged in a struggle. The mermaid, with her siren-like beauty and potential of menace (as here, where she has dragged a drowned sailor to the bottom of the sea) was a popular nineteenth-century *femme fatale* image among a number of Pre-Raphaelite followers, such as John William Waterhouse, and to Symbolists including Gustave Klimt.

The artist's interest in mermaids developed particularly after his acquisition of his seaside home in Rottingdean. There he created a 'tavern' which he called 'The Merry Mermaid', and turned frequently to the motif in various sketches and watercolours, one of which, formerly owned by Burne-Jones's young friend Katie Lewis, is now in the Tate Gallery, and produced a mermaid drawing (Victoria & Albert Museum) that was made into an apparently unrealized wallpaper design (William Morris Gallery, Walthamstow). There are reasons to believe that the head of the mermaid was modelled by Laura Tennant (one the subjects in *The Golden Stairs*), the wife of Alfred Lyttleton, who died in 1886 while the oil was being painted, Burne-Jones telling Alfred, 'I am painting a scene in Laura's previous existence.' Gerard Manley Hopkins saw *The Depths of the Sea* at the Royal Academy and wrote to a friend, 'You speak of powerful drawing. I recognize it in that mermaid's face and in the treatment of her fishnets and fishermanship, the tailfin turning short and flattening to save striking the ground – the stroke of truly artistic genius.'

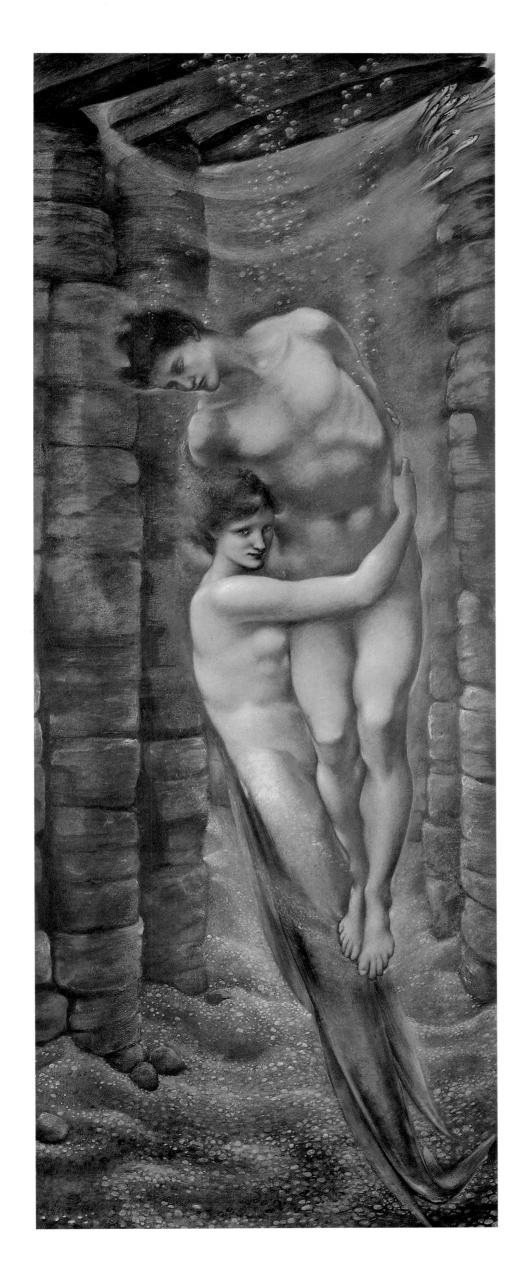

PLATE 27

THE ARMING OF PERSEUS
————— 1885–88 —————
Oil (unfinished), 60.2 x 50 in / 153.x 127 cm
Private collection

Perseus was a series of paintings commissioned in 1875 by Arthur Balfour, a wealthy politician (and later British Prime Minister) who had previously acquired his *Wheel of Fortune*, for display in the music room of his London house at 4 Carlton Gardens. Burne-Jones selected the subjects from his earlier treatment of the legends associated with Perseus, the offspring of Danaë and Zeus, as illustrations for Morris's *The Earthly Paradise*. The subjects were modified as work progressed slowly over many years, with eight large paintings and a range of extra decorative details indicated in his drawings of the entire room (now in the Tate Gallery). Burne-Jones worked on a set of full-sized cartoons (Southampton City Art Gallery) until 1885, when he turned his attention to the oil versions, but the ambitious series was never completed. W. Graham Robertson, on his first visit to The Grange, described seeing them in progress, scattered throughout his studio. The paintings were acquired by Huntington Hartford and in 1972 sold to the Staatsgalerie, Stuttgart. In this, the third work from the cycle, Perseus meets the Nereides or sea nymphs who arm him with the winged sandals of Hermes, a helmet to make him invisible and a bag in which to place the head of the gorgon Medusa. The nymph on the far right is has been identified as modelled by Frances Graham, the daughter of his patron William Graham, and one of his many close female friends.

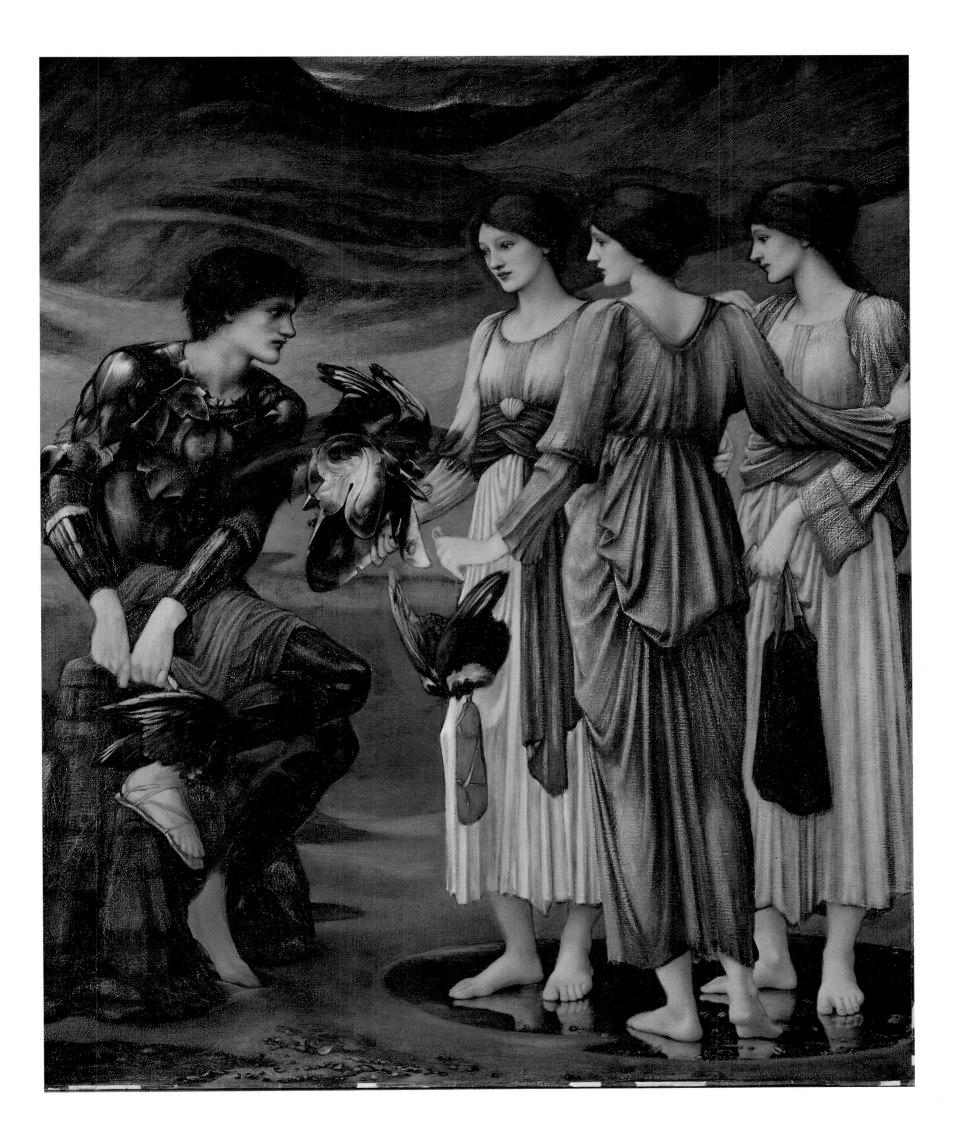

PLATE 28

THE ROCK OF DOOM
———— 1885 – 88 ————
Oil, 61 x 51.2 in / 155 x 130 cm
Staatsgalerie, Stuttgart

In the Perseus legend, after vanquishing and escaping with the head
of Medusa, Perseus journeys to Joppa where he finds, rescues and
marries Andromeda, who had been chained to a rock as a sacrifice to
a sea monster after her mother Cassiopeia had offended the gods.
This work was exhibited in 1888 at the New Gallery, London, a
newly-established venture that had been set up following a schism
among the directors of the Grosvenor Gallery.

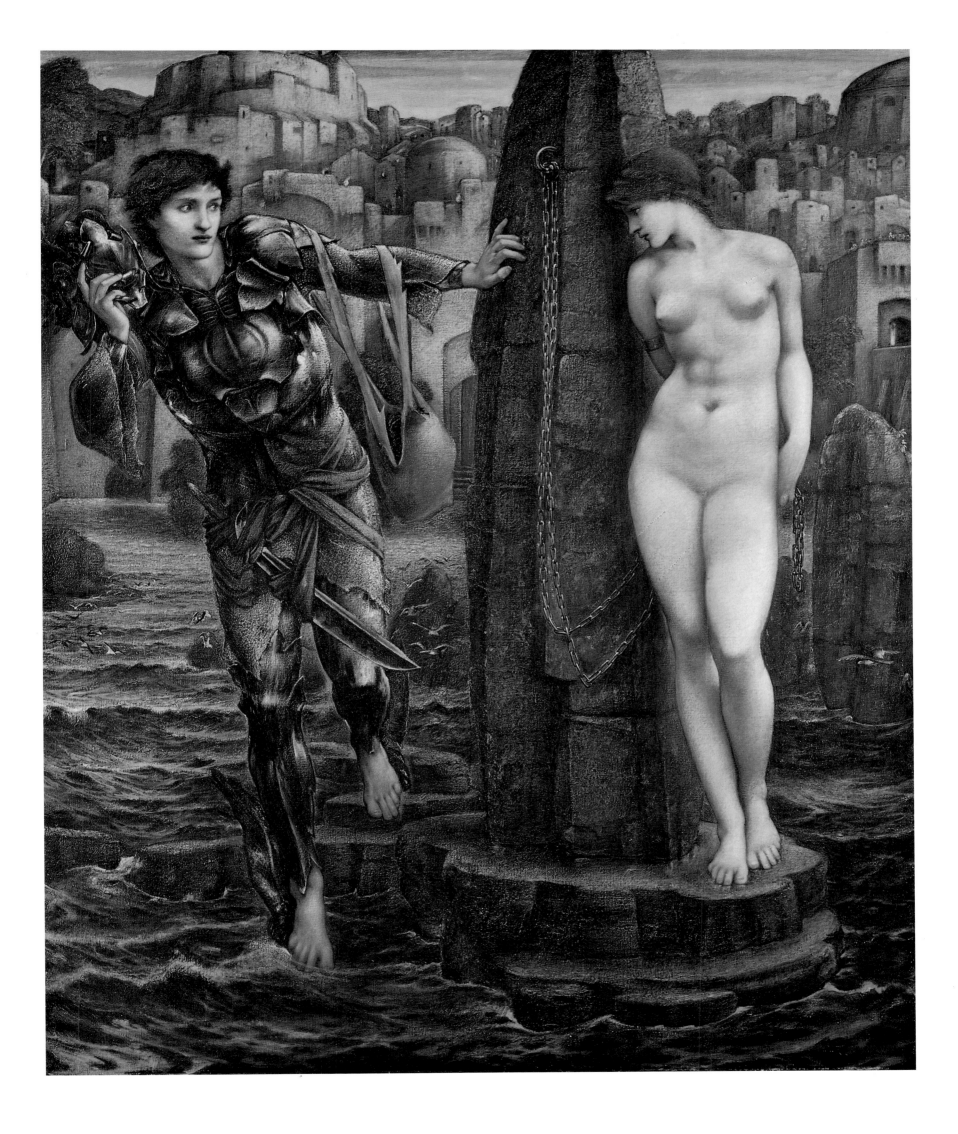

PLATE 29

THE BALEFUL HEAD
———— 1886–87 ————
Oil, 61.4 x 50.4 in / 156 x 128 cm
Staatsgalerie, Stuttgart

Although chronologically later in the Perseus cycle, *The Baleful Head* was one of the first to be finished – if any of them can be described as finished, since Burne-Jones continued to tinker with them until his death, and Balfour's patience over the 23 years on which Burne-Jones worked on his commission is to be admired. The work, which was exhibited at the Grosvenor Gallery in 1887, shows Perseus with his wife Andromeda viewing the reflection of Medusa's head in a well, as a way of avoiding the direct gaze of the gorgon whose glance would otherwise have turned them to stone. The head of Medusa was based on a portrait of the daughter of Burne-Jones's friend W.A.S. Benson.

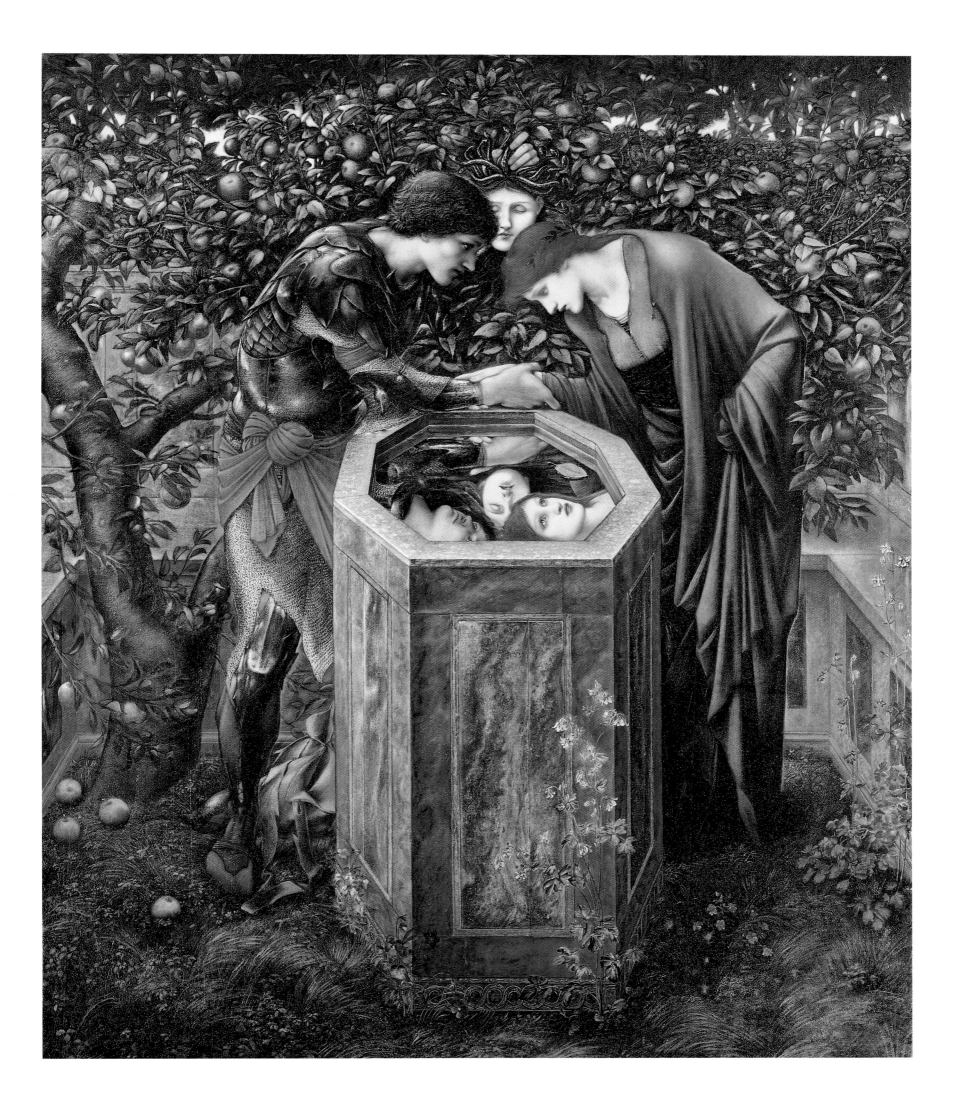

PLATE 30

DANAE AND THE BRAZEN TOWER
———————————— 1887–88 ————————————
Oil, 91 x 44.5 in / 231.1 x 113 cm
Glasgow Museums: Art Gallery and Museum, Kelvingrove

The painting recounts a scene from the legend of King Acrisius of Argos, who was warned by an oracle that he would be slain by the son of his daughter Danaë. So that she could not have children, he incarcerated her in a brazen tower, but there she produced a son, Perseus, fathered by Zeus who visited her in a shower of gold. Acrisius hurled the baby into the sea in a wooden chest, but Perseus was rescued, returned as an adult and, during games, accidentally killed his grandfather with a discus, thus fulfilling the prophecy. The story is told in Morris's *Earthly Paradise*, while the painting portrays Danaë watching as the tower is constructed. The head of Danaë, with the typical nervous, hesitant hand to her face, was modelled by Marie Spartali, Maria Zambaco's cousin, who Burne-Jones considered the most beautiful model of all, and who also sat for several other works, including *The Mill* (Plate 20). Other versions exist in the Ashmolean Museum, Oxford, and the Fogg Art Museum, Harvard University.

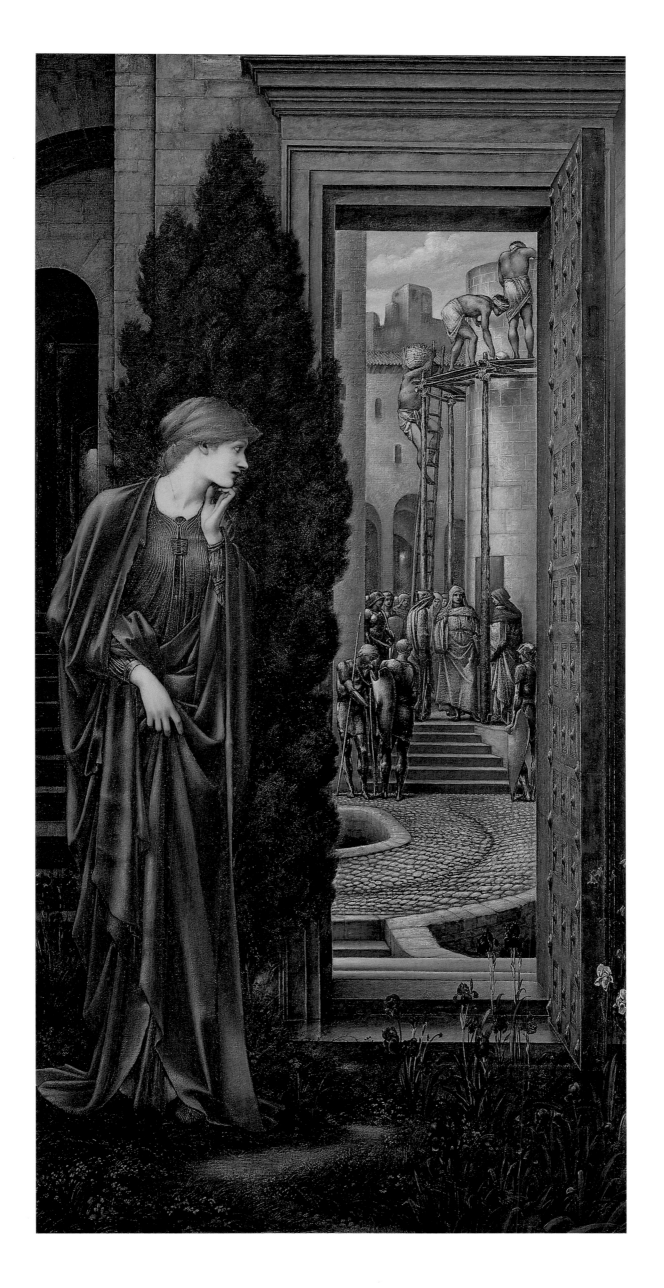

THE BRIAR ROSE—THE PRINCE ENTERS THE BRIAR WOOD

—————— 1870–90 ——————

Oil, 48 x 98 in / 121.9 x 249 cm
Faringdon Collection, Buscot Park, Berkshire

In the 1860s Burne-Jones created designs for a series of tiles based on the story of Sleeping Beauty, as told by Charles Perrault. From these in 1870–73 he developed a series of three small paintings for William Graham (now in the Museo de Arte, Ponce, Puerto Rico), and four larger works which occupied him intermittently from 1870 to 1890. The figure of Sleeping Beauty was modelled by Margaret Burne-Jones, and several writers have observed the psychological link between the story and Burne-Jones's own aspirations, as one of arrested ageing and protecting his virginal daughter from being violated. In an attempt to make the briar wood as threatening as possible, he had prickly thorns sent to his studio from the garden of his friend Lady Leighton, requesting an example as 'thick as a wrist and with long, horrible spikes on it.'

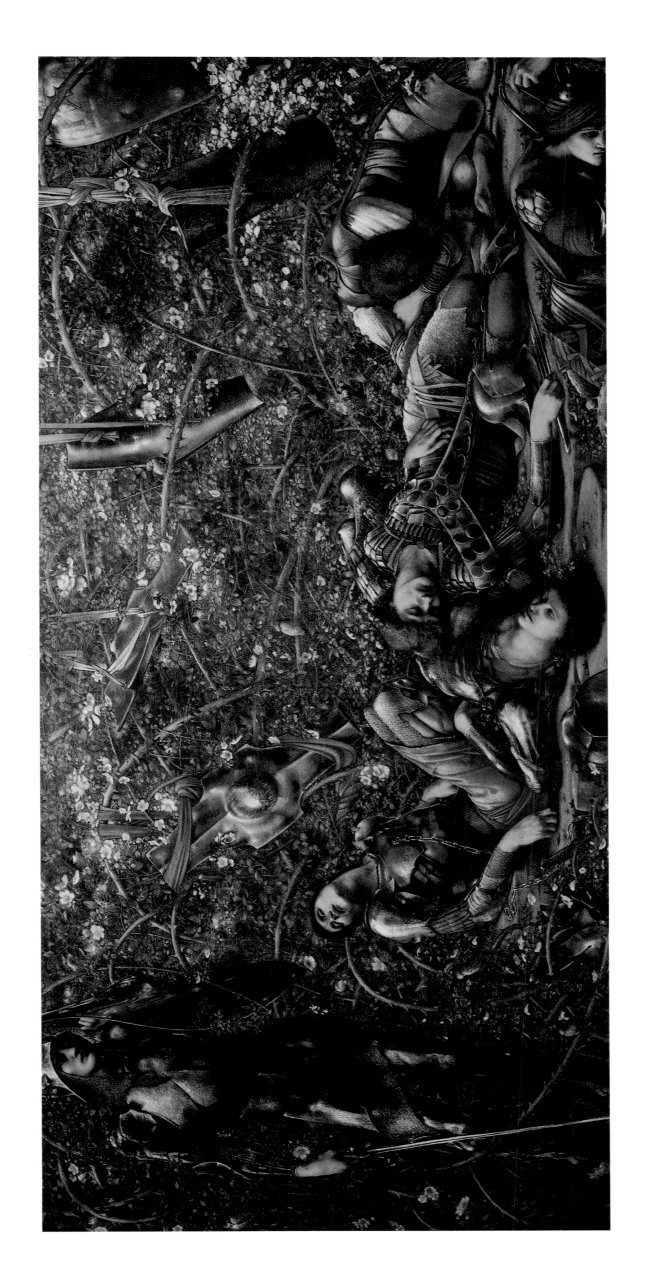

PLATE 32

THE BRIAR ROSE—THE SLEEPING PRINCESS

———————— 1870–90 ————————

Oil, 48 x 90 in / 121.9 x 228.6 cm
Faringdon Collection, Buscot Park, Berkshire

The series, embellished with descriptive verses by William Morris beneath each painting, entered the collection of the financier Alexander Henderson, later Lord Faringdon, who paid £15,000 for it, making it one of the most valuable commissions of the era. When the *Briar Rose* paintings were exhibited at Agnews in 1890, the *Times* critic was enthusiastic: 'We are accustomed to this evidence of loving care in Mr Burne-Jones's pictures, but it has never been shown before on so large a scale and with such exuberance of fancy as in these four pictures. The world of dreams and fairies has surely never been so prodigally illustrated.' After this show, and as a gesture to the poor of East London, the works were displayed free of charge at Toynbee Hall in Whitechapel before being installed at Buscot Park, which Henderson had recently bought. Burne-Jones later added intervening scenes to create a decorative frieze. Numerous studies are dispersed in various private and public collections with full-sized versions in Bristol, Dublin and elsewhere.

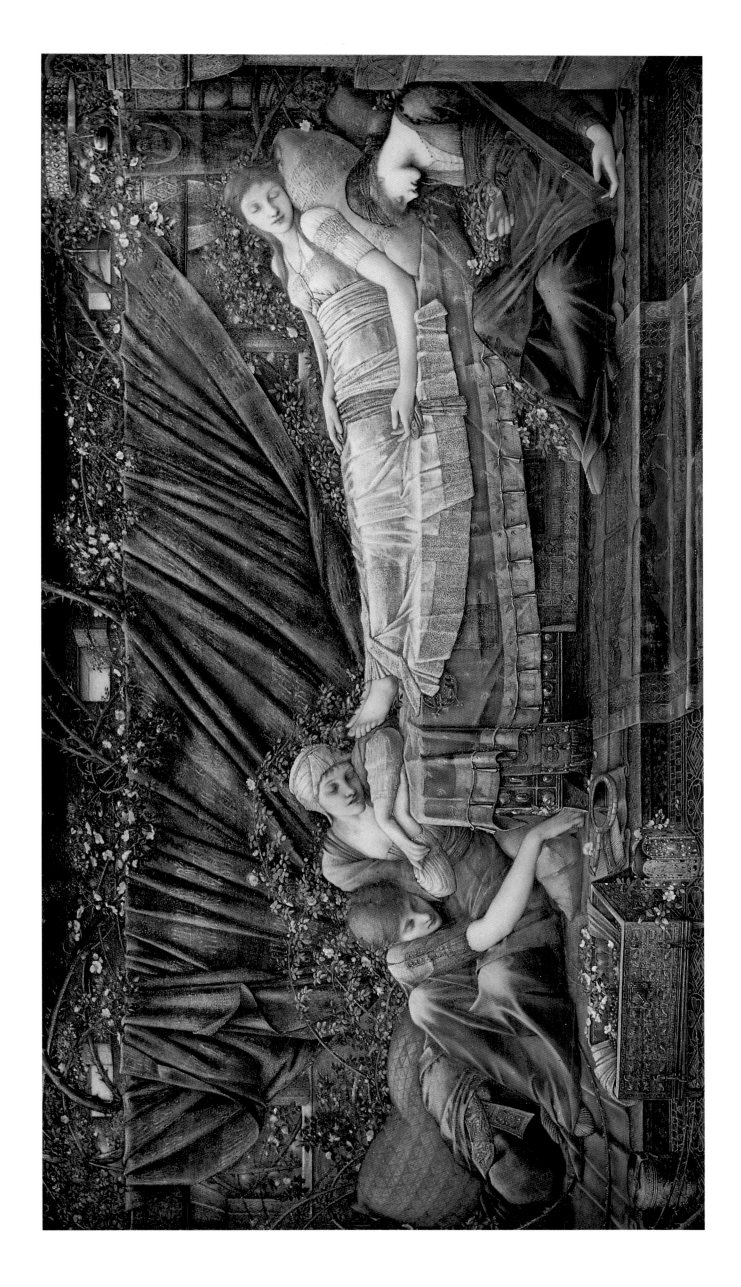

PLATE 33

THE STAR OF BETHLEHEM

———————— 1888–91 ————————

Watercolour, oil, tempera and gouache on paper, laid onto canvas,
101 x 152 in / 256.5 x 386 cm
Birmingham Museums and Art Gallery

The nativity was a subject to which Burne-Jones turned on a number
of occasions for stained-glass commissions. After Morris opened his
tapestry-weaving workshops at Merton Abbey in 1881, several such
designs had a further life as textiles, and this subject, created in 1887
(the cartoon for which is in the Victoria & Albert Museum), was
supplied as a tapestry to such locations as the chapel of Exeter
College, Oxford (which Burne-Jones and Morris had attended in the
1850s), Eton College Chapel and Norwich Castle. In this instance,
however, the process was also reversed when, commissioned by
Birmingham Corporation, the tapestry design was re-worked as an
unusually large-scale watercolour. It was so tall that it required
Burne-Jones to work on the upper parts of it on a mobile ladder, as
recorded in a photograph by Barbara Leighton. Aptly, while he was
working on the subject his own daughter Margaret gave birth to
Angela Mackail (known in later life as the novelist Angela Thirkell).

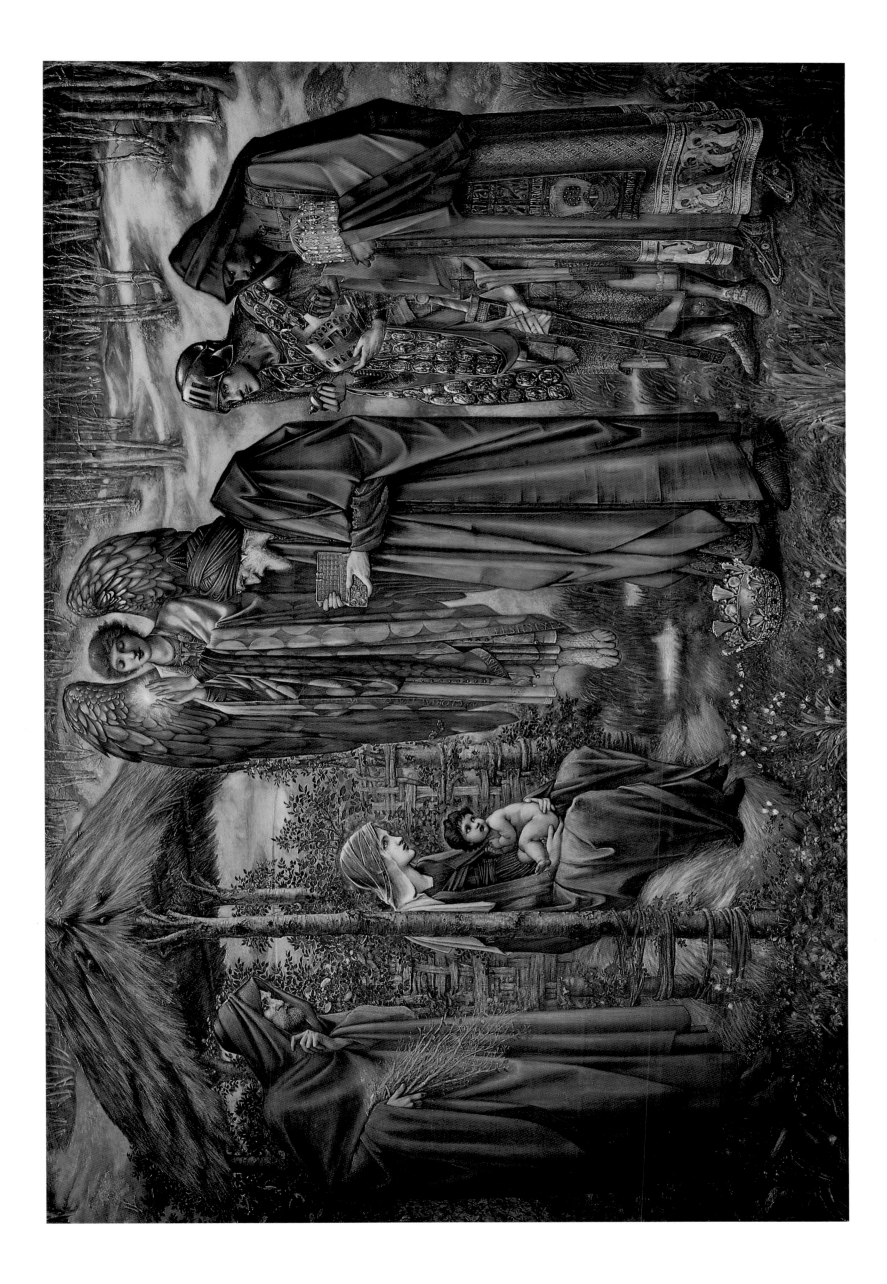

SPONSA DE LIBANO
———— 1891 ————
Watercolour, tempera and gouache, 130.9 x 61.22 in / 332.5 x 155.5 cm
National Museums and Galleries on Merseyside
(Walker Art Gallery, Liverpool)

Sponsa de Libano, 'The Bride of Lebanon', is an illustration of passages from the biblical *Song of Solomon*: 'Come with me from Lebanon, my spouse' and 'Awake, O north wind, and come, thou south.' Burne-Jones originally created it in the 1870s for embroidery designs, in which winds urge the bride onward, with swaying lilies beside the stream. He then developed it into this watercolour, using an unnamed girl from Houndsditch to blow out her cheeks as a model for the wind — with clear echoes of the winds in Botticelli's *The Birth of Venus*.

PLATE 35

VESPERTINA QUIES

———— 1893 ————

Oil, 42.5 x 24.5 in / 108 x 62.2 cm
Tate Gallery, London

The model for this portrait, the title of which means 'Evening Repose', was Bessie Keene, a young woman whose mother had previously sat for Burne-Jones. The enigmatic expression, reminiscent of that in *The Depths of the Sea*, and the landscape background, are obviously homages to Leonardo da Vinci's *Mona Lisa*.

Maud Beddington, one of the many young female artists whom Burne-Jones advised, watched him at work on *Vespertina Quies* and described his technique: 'He began by drawing the figure in raw umber…then he modelled the face in white and raw umber, lightly putting a little red on the lips, nostril and eyes – the blue of the frock and all the strong colours were painted in sweeping strokes of full colour. He used a mixture of spike [lavender] oil and turpentine as a medium. He used flat brushes to keep his canvas smooth.'

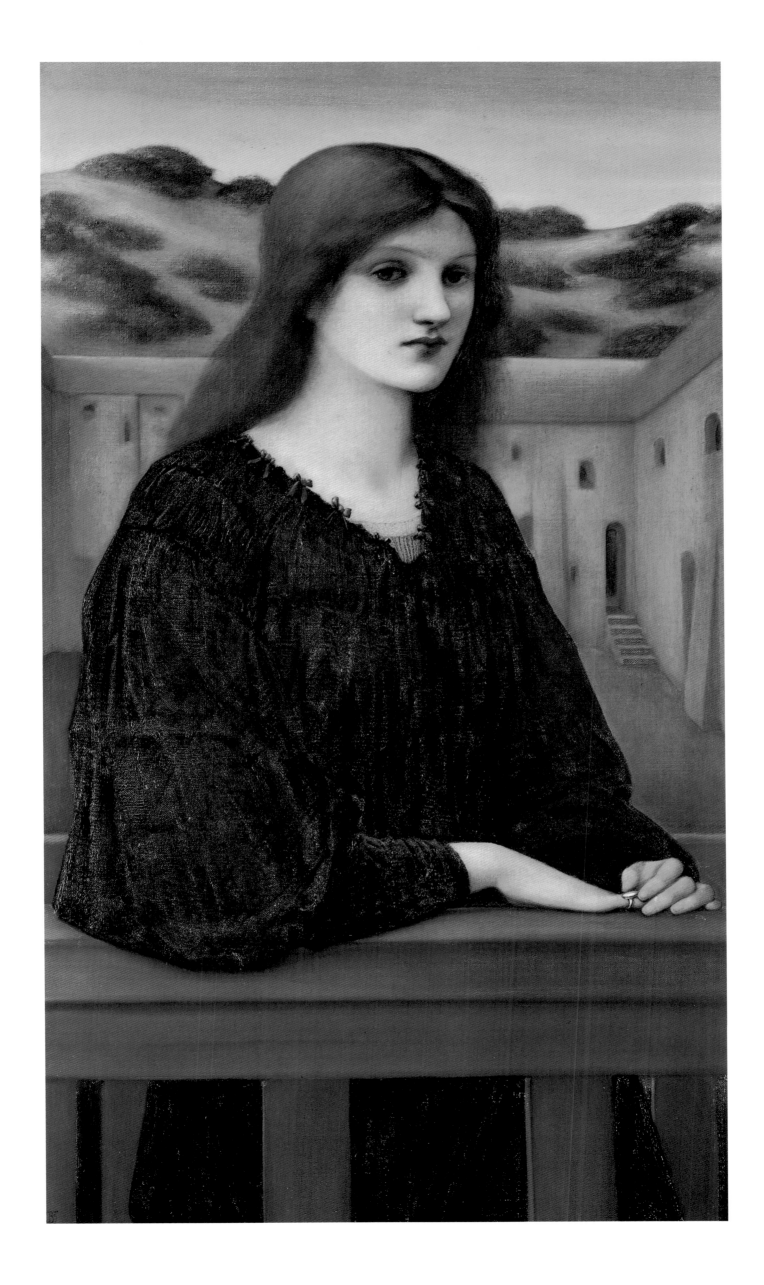

LOVE AMONG THE RUINS
———————— 1894 ————————
Oil, 37.5 x 63 in / 95.3 x 160 cm
National Trust: Wightwick Manor near Wolverhampton

Although Browning wrote a poem of the same title, the work does not represent any specific literary incident. Many observers have noted the sadness that pervades most of Burne-Jones's work, and his figures are invariably either melancholy or expressionless. He himself commented, 'The moment you give what people call expression, you destroy the typical character of heads and degrade them into portraits which stand for nothing.' One of only two works exhibited in the seven years following the Old Water-Colour Society incident of 1870, it was shown, with *The Hesperides*, at the Dudley Gallery. An earlier gouache version (1870–73) was painted after his parting from Maria Zambaco, who appears as the woman, while the model Gaetano Meo sat for the lover. This was sent to Boussod & Valadon (the Paris company for which Theo and Vincent van Gogh had worked) in 1893. When it was being photographed there, mistaking the thick water-based paint for oil, egg white was brushed onto it to enhance the highlights, which had the effect of dissolving the surface. Burne-Jones was anguished by the damage, but immediately started work on this oil replica. In the last months of his life he discovered that by cleaning with ox gall and repainting he was able to restore the original gouache, which is now in a private collection.

PLATE 37

ANGELI LAUDANTES
———— 1894 ————
Tapestry, 93 x 72.8 in / 236.2 x 185 cm
Victoria & Albert Museum, London

In the 1880s and early 1890s, William Morris's Merton Abbey work-shops produced several tapestries based on designs derived from pictures by Burne-Jones, especially for ecclesiastical commissions. These were usually reproduced photographically from smaller cartoons, some of which had previously been produced for stained glass. *Angeli Laudantes* was originally created in 1878 as a coloured chalk cartoon (once owned by Arthur Balfour and now in the Fitzwilliam Museum) for one of two windows in the south choir aisle of Salisbury Cathedral. The other, *Angeli Ministrantes*, also became a tapestry. Even thus distanced from Burne-Jones's original design, it retains his characteristic style and much of its power.

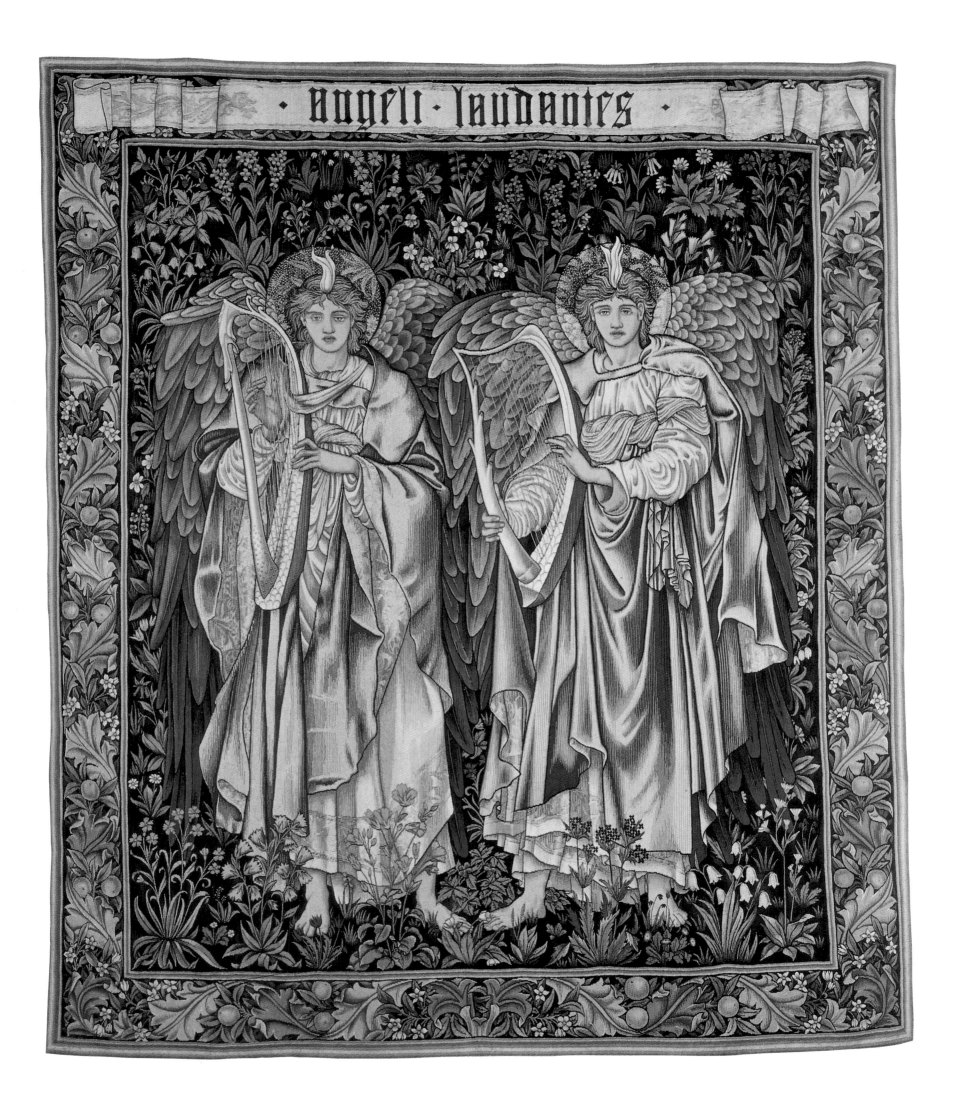

PLATE 38

THE WEDDING OF PSYCHE
———————— 1894 – 95 ————————
Oil, 48 x 84 in / 122 x 213.4 cm
Musées royeaux des Beaux-Arts de Belgique

Like *Pan and Psyche* (Plate 9), *The Wedding of Psyche* originated with illustrations for *The Earthly Paradise*. The scattering of roses in the wedding procession recalls his own daughter Margaret's wedding at St Margaret's church, Rottingdean, in 1888, when, as Georgiana recalled, 'the way to the church door was thronged with people out of whom came four damsels in white with big baskets of rose-leaves, which they shed over the pathway.'

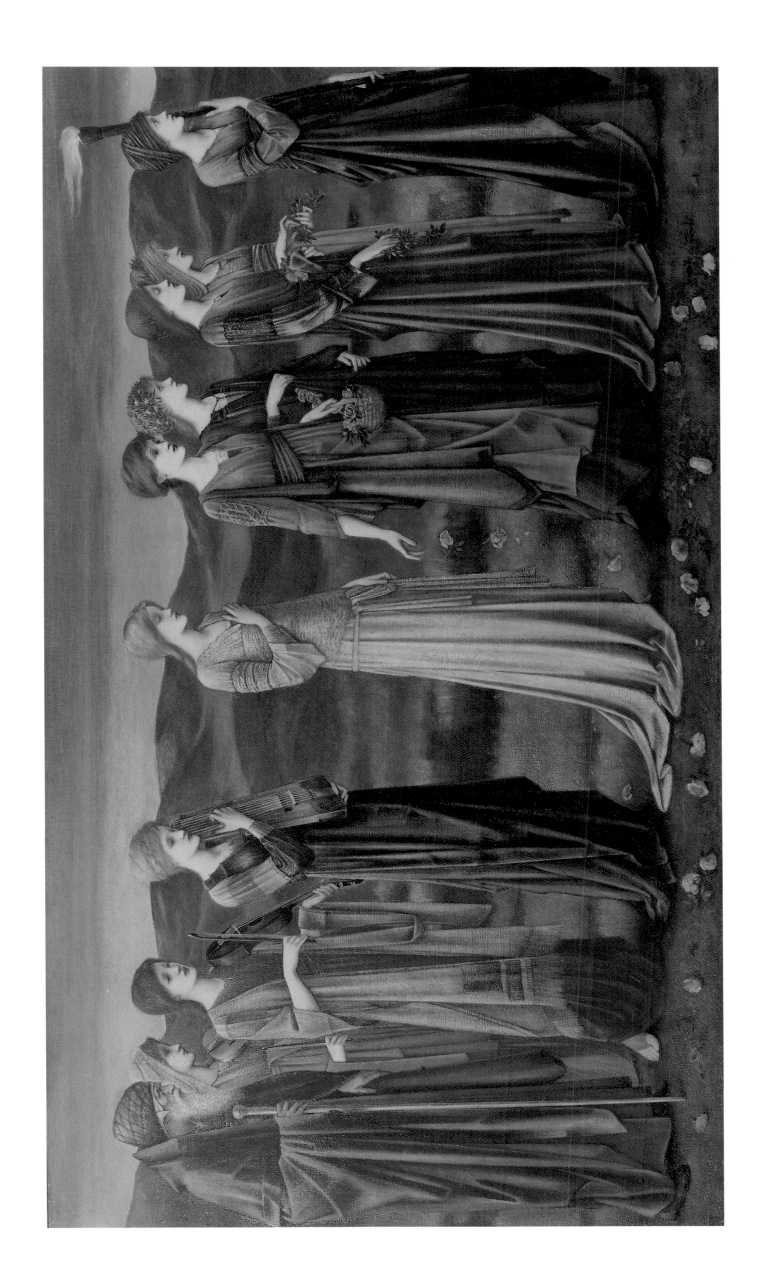

PLATE 39

LOVE LEADING THE PILGRIM
———————— 1896–97 ————————
Oil, 61.8 x 119.7 in / 157 x 304 cm
Tate Gallery, London

Once again Chaucer provided the literary inspiration for a painting, in this instance a scene from his *Romaunt of the Rose*, which Burne-Jones had formerly used for one of the panels of a needlework frieze which he designed in collaboration with William Morris. Embroidered in 1880 by Margaret Bell, the wife of Sir Lowthian Bell, and her daughter Florence Johnson for the dining room at Rounton Grange, Northallerton, it is now in the William Morris Gallery, London. In common with a number of Burne-Jones's major compositions, it progressed slowly: the design dates from the early 1870s, with the painting beginning in 1877, but he continued to work on it during the next twenty years, completing it only in the year before his death and dedicating it to Swinburne, exhibiting it at the New Gallery in that year. In response to a comment by his son Philip Burne-Jones that the work appeared 'cold and miserable', he lightened it. An Italian model called Giacinto sat for the Pilgrim; he was originally bearded, but this too was later altered. Thomas Rooke's studio diary of the years 1895–98 makes frequent reference to Burne-Jones's continuous work, adding details to the work over the last years of its development, anguishing over every element of the design. Even then he did not want to finish it and spoke of wanting to take 'a great big bottle of benzene and go over it and wash it all away', but a comment to Rooke was also recorded by Georgiana: 'It's nice to finish an old thing. What Mr Morris said the other day was very true; he said, "The best way of lengthening out the rest of our days now, old chap, is to finish off our old things."' Originally sold for £5,775, the painting was later acquired by the Duchess of Sutherland. However, in subsequent years Burne-Jones's star faded so much that when the National Art Collections Fund bought it in 1943 (presenting it to the Tate), they paid just £94 10s.

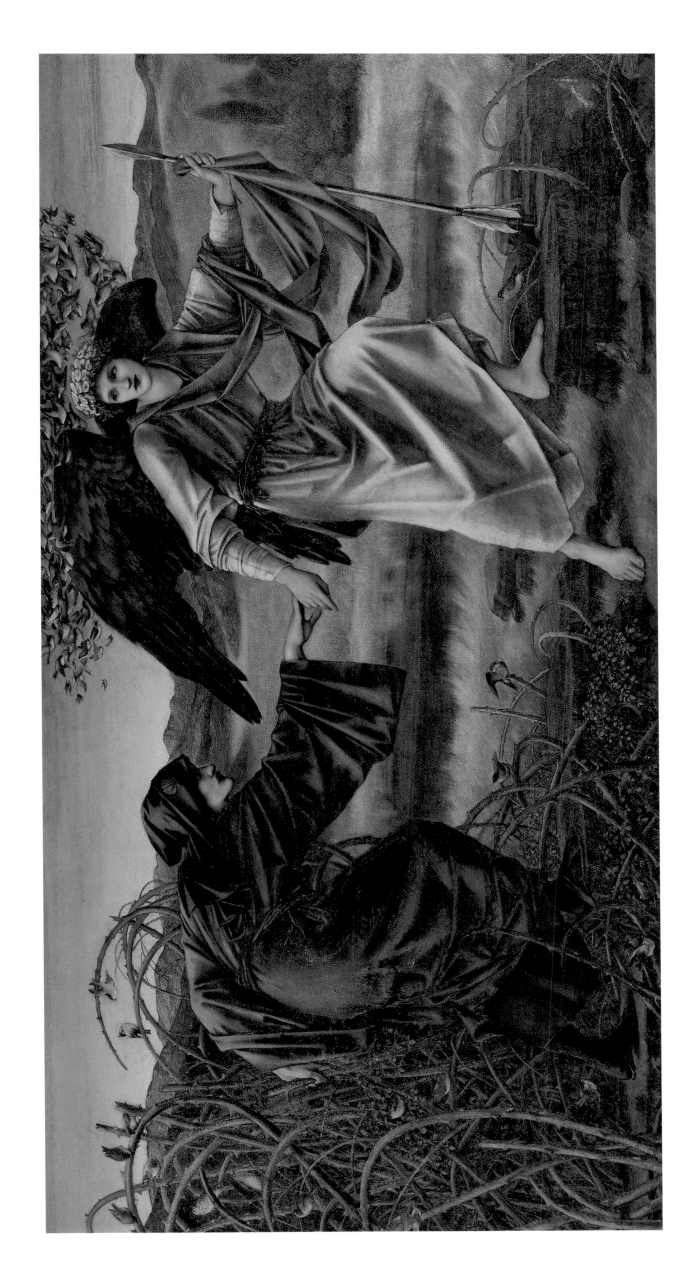

PLATE 40

THE PRIORESS'S TALE
———————— 1865–98 ————————
Gouache on paper, 40.9 x 24.8 in / 104 x 63 cm
Samuel and Mary Bancroft Collection, Delaware Art Museum, Wilmington

Exhibited at the New Gallery in the last show before his death in 1898, this work depicts the story of a seven-year-old boy whose throat was cut for singing a Christian song in a Jewish city in Asia, but miraculously continued to sing when the Virgin Mary placed grain in his mouth. He died soon afterwards and was buried as a martyr. The flower symbolism of the white lily represents purity, that of the red poppy consolation, the dwarf sunflower adoration and the wallflower fidelity in adversity. A variation on the theme appears in the Kelmscott *Chaucer*, but in this work Burne-Jones's painting has come full-circle, the subject of his first oil painting becoming almost one of his last. It is also one of the best examples of how doggedly he clung to his compositions, since although this work spanned the period from 1865 to 1898, the original conception dates from even earlier, from 1858, when he created it in oil on a cabinet (now in the Victoria & Albert Museum) designed by Philip Webb the previous year and given in 1860 to William and Jane Morris as a wedding present. Georgiana, writing during Burne-Jones's final year of life, has the last word:

'The picture from Chaucer's *Prioress's Tale* which Edward completed this spring was the one designed in Red Lion Square forty years before, and the compositions of the Virgin and the little Christian boy remains exactly as he drew them – his vision had not changed. The background, however, is altered, a city replacing the landscape. As he was fitting in the poppies that grow up in front of and around the figures, some one remarked upon the importance of first lines in a composition. "Yes," he said, "they come straight from the heart."'

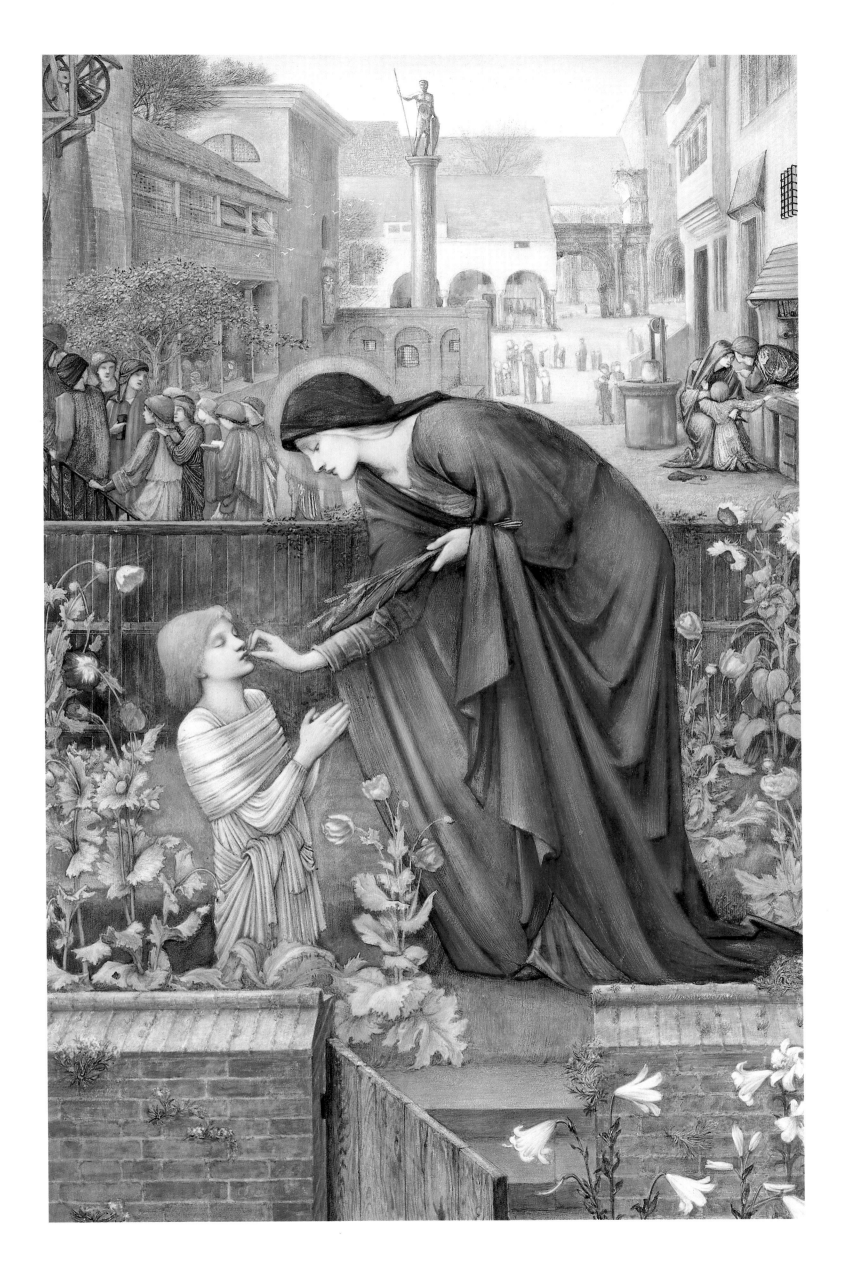

SELECT BIBLIOGRAPHY

The Arts Council of Great Britain,
Burne-Jones (exhibition catalogue)
London: Arts Council, 1975

Malcolm Bell, *Sir Edward Burne-Jones:*
A Record and Review
London: George Bell & Sons, 1903

Edward Burne-Jones, *Letters to Katie*
London: British Museum Publications, 1988

Georgiana Burne-Jones, *Memorials of Edward*
Burne-Jones
London: Macmillan & Co., 1904

David Cecil, *Visionary & Dreamer: Two Poetic*
Painters, Samuel Palmer and Edward Burne-Jones
London: Constable, 1969

Gay Daly, *Pre-Raphaelites in Love*
New York: Ticknor & Fields, 1989

Penelope Fitzgerald, *Edward Burne-Jones:*
A Biography
London: Michael Joseph, 1975

William Gaunt, *The Pre-Raphaelite Tragedy*
London: Jonathan Cape, 1942

Martin Harrison & Bill Waters, *Burne-Jones*
London: Barrie & Jenkins, 1973; revised
edition, 1977

Mary Lago (ed.), *Burne-Jones Talking: His*
conversations 1895–1898 Preserved by his Studio
Assistant Thomas Rooke
London: John Murray, 1982

W. Graham Robertson, *Time Was*
London: Hamish Hamilton, 1931

William Waters, *Burne-Jones*, Aylesbury:
Shire Publications, 1973

PRINCIPAL PUBLIC COLLECTIONS CONTAINING WORKS BY BURNE-JONES

AUSTRALIA

Adelaide
National Gallery of South Australia

Brisbane
Queensland Art Gallery

Melbourne
National Gallery of Victoria

Sydney
Art Gallery of New South Wales

BELGIUM

Brussels
Le Musée d'Art Moderne

FRANCE

Paris
Musée d'Orsay

GERMANY

Neuss
Clemens-Sels-Museum

Stuttgart
Staatsgalerie

GREAT BRITAIN

Bedford
Cecil Higgins Art Gallery

Birmingham
Birmingham City Art Gallery

Bristol
City Art Gallery

Cambridge
Fitzwilliam Museum

Cardiff
National Museum of Wales

Carlisle
Museum and Art Gallery

Compton
Watts Gallery

Faringdon
Buscot Park

Glasgow
Art Gallery

Liverpool
Walker Art Gallery

London
British Museum
Hammersmith Public Libraries
William Morris Gallery
Tate Gallery
Victoria & Albert Museum

Manchester
City Art Gallery
Whitworth Art Gallery

Newcastle upon Tyne
Laing Art Gallery

Norwich
Castle Museum

Oxford
Ashmolean Museum

Port Sunlight
Lady Lever Art Gallery

Sheffield
City Art Gallery

Southampton
Southampton Art Gallery

Wolverhampton
Wightwick Manor

IRELAND

Dublin
National Gallery of Ireland

PORTUGAL

Lisbon
Calouste Gulbenkian Foundation

PUERTO RICO

Ponce
Museo de Arte

SOUTH AFRICA

Cape Town
National Gallery of South Africa

UNITED STATES OF AMERICA

Boston, Massachusetts
Museum of Fine Arts

Cambridge, Massachusetts
Fogg Art Museum, Harvard University

Chicago, Illinois
Art Institute of Chicago

New York
The Metropolitan Museum of Art

Wilmington, Delaware
Delaware Art Museum